INTIMACY

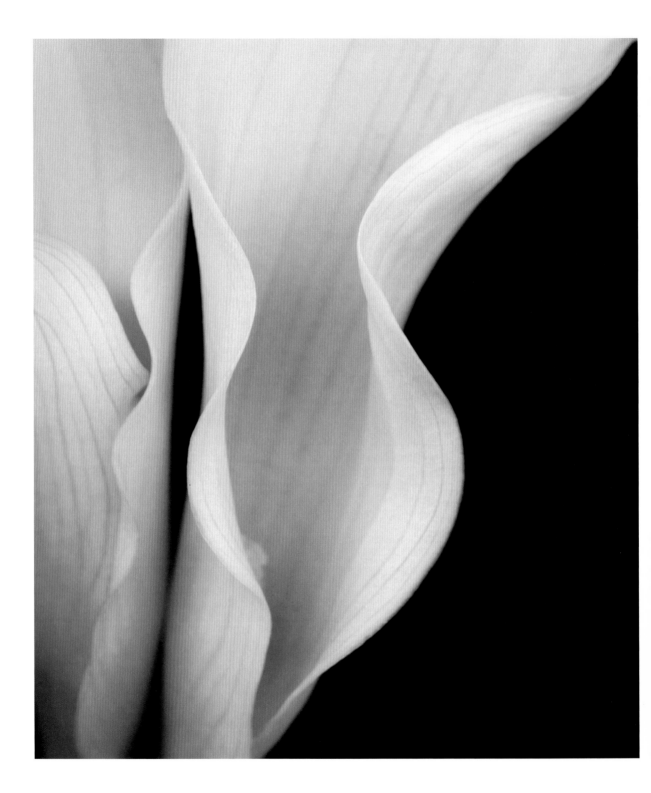

INTIMACY

The Sensual Essence of Flowers

JOYCE TENNESON

BARNES & NOBLE BOOKS
NEW YORK

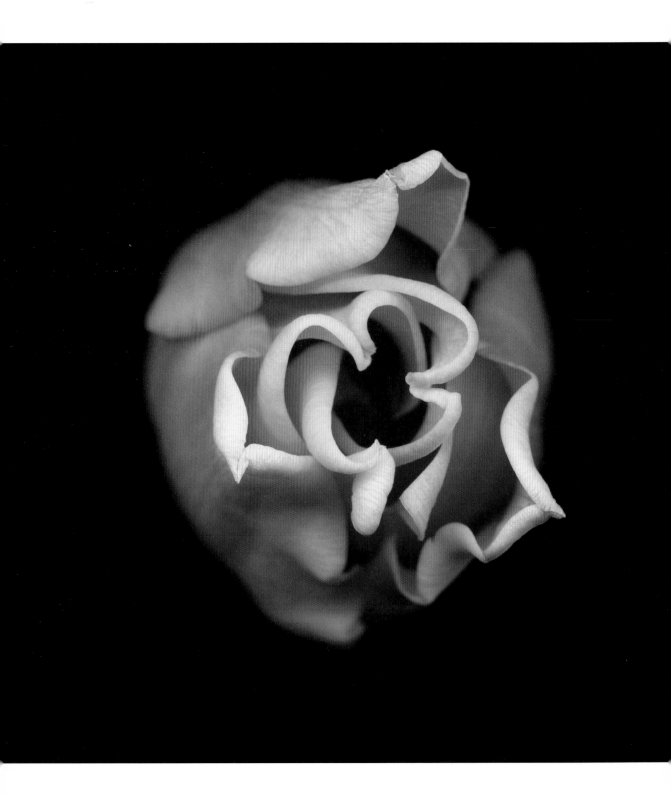

plate I

Photographing these flowers has
made me see the world differently. It
was as if I had lifted a secret veil from a
subject I had loved and appreciated my
whole life. I offer these photographs with
the hope that they will open a new
visual or meditative universe
for you as well...

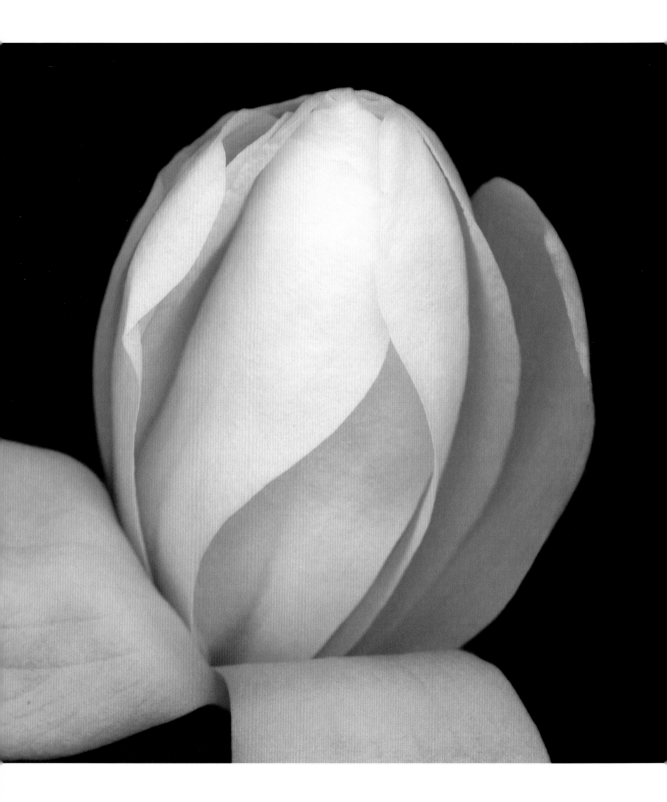

plate 2

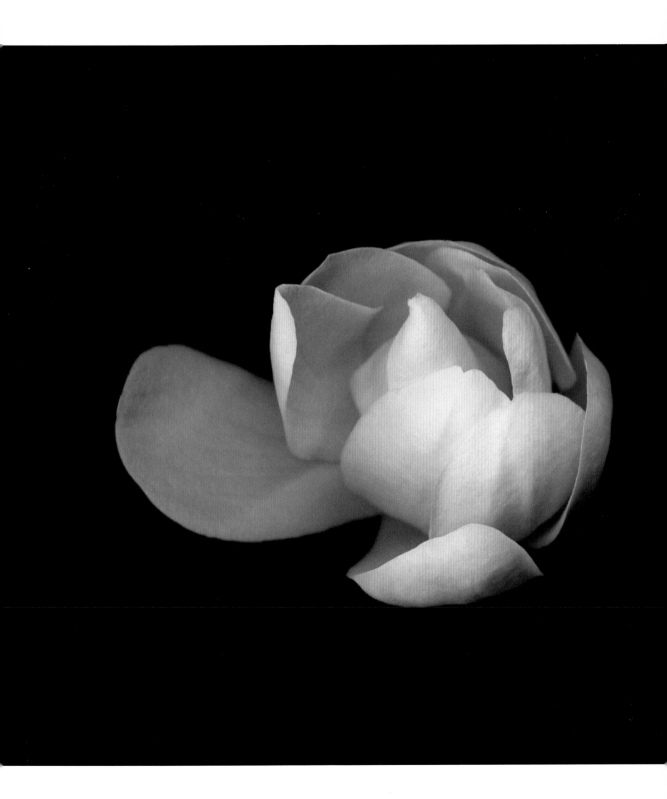

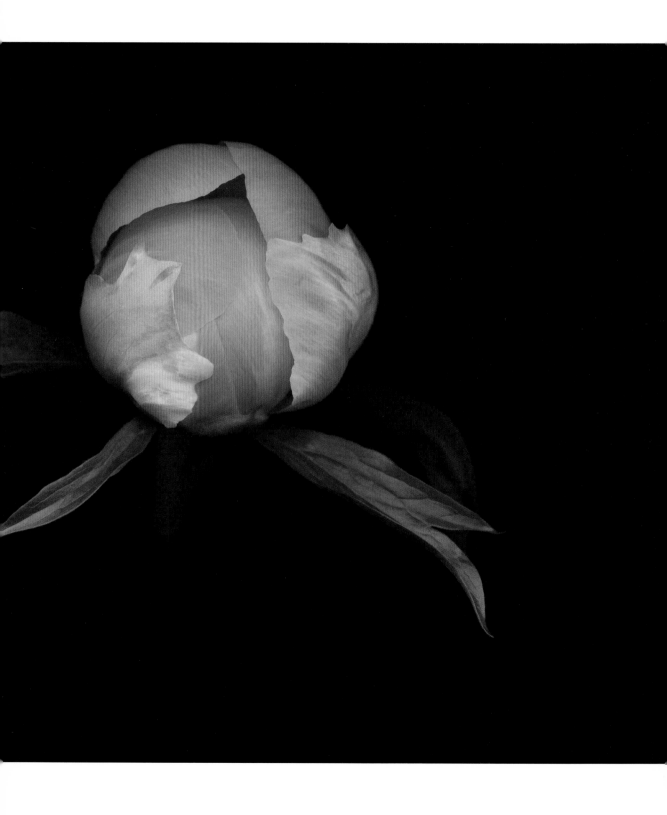

plate 3

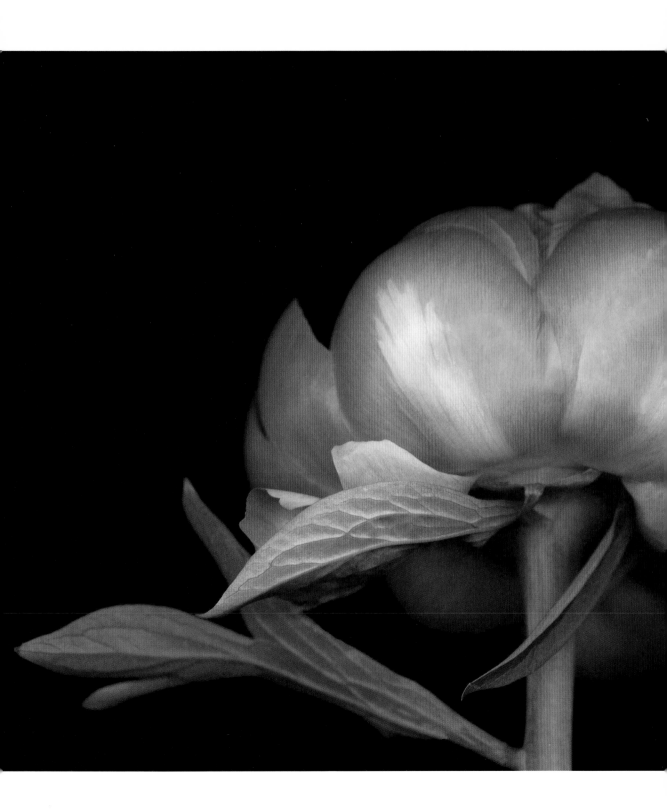

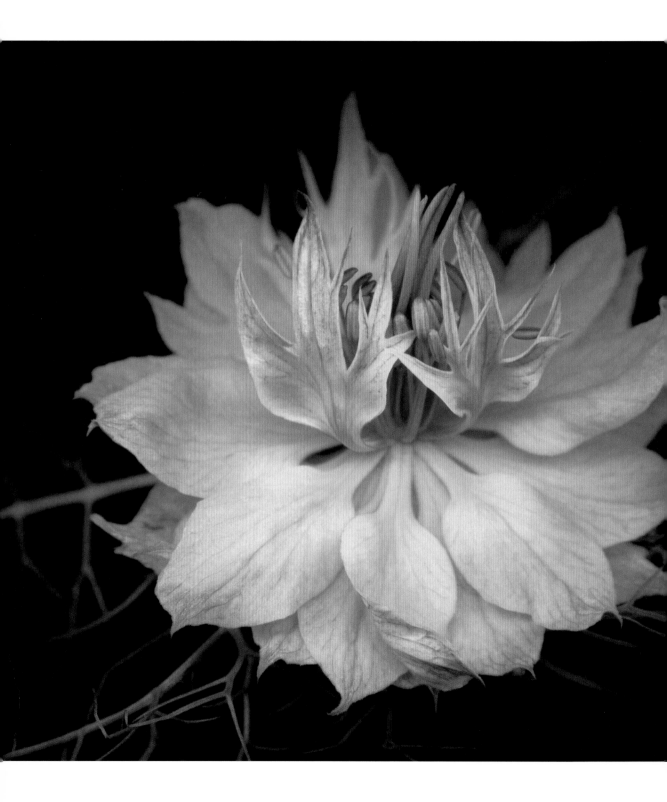

plate 4

It is at the edge of the
petal that love waits.

<small>WILLIAM CARLOS WILLIAMS</small>

plate 5

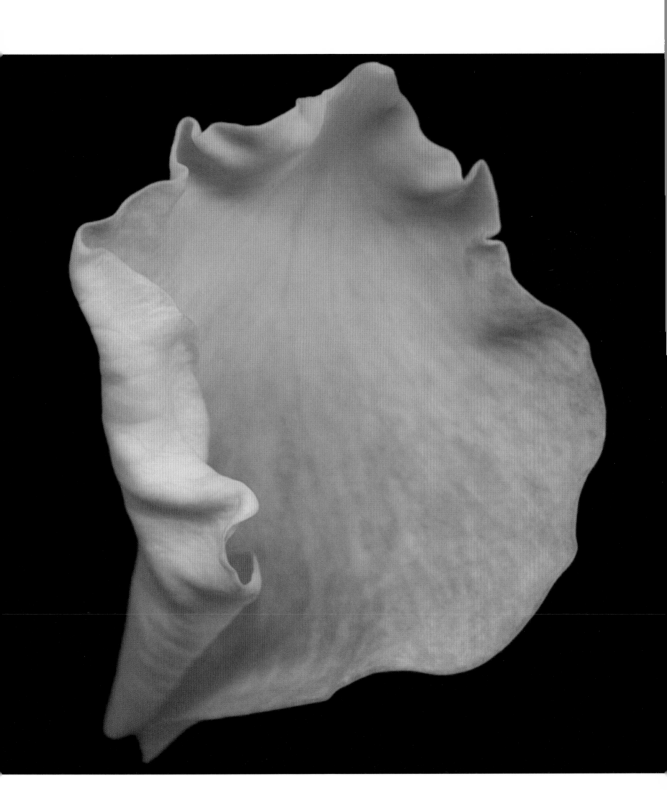

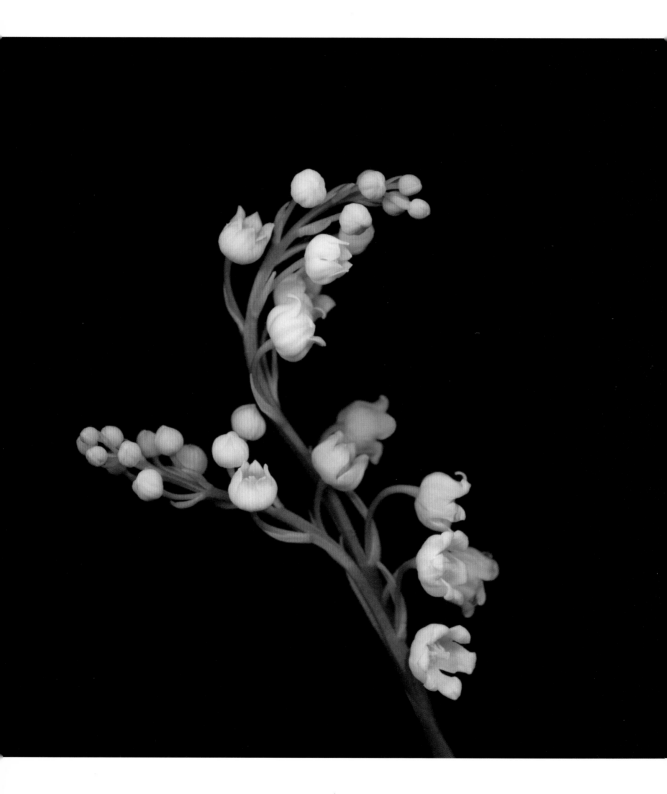

plate 6

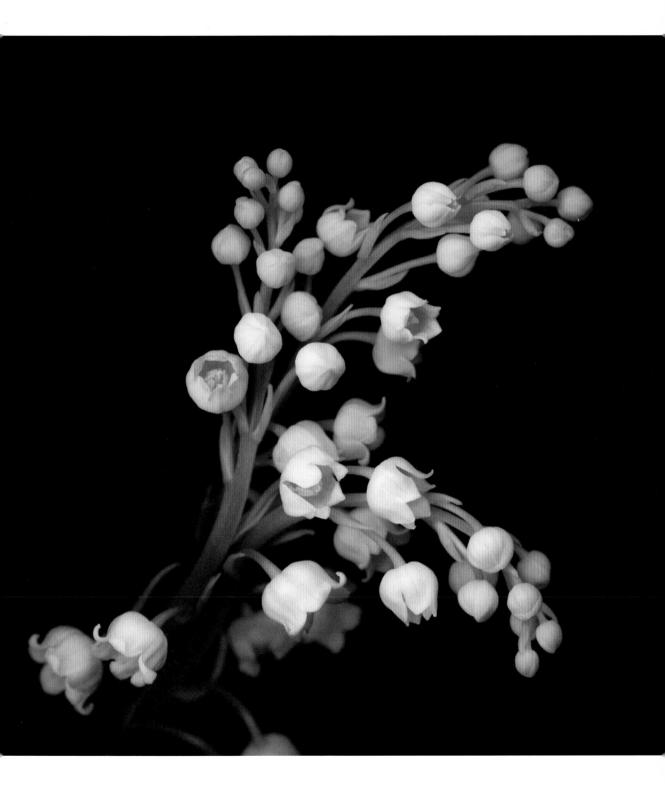

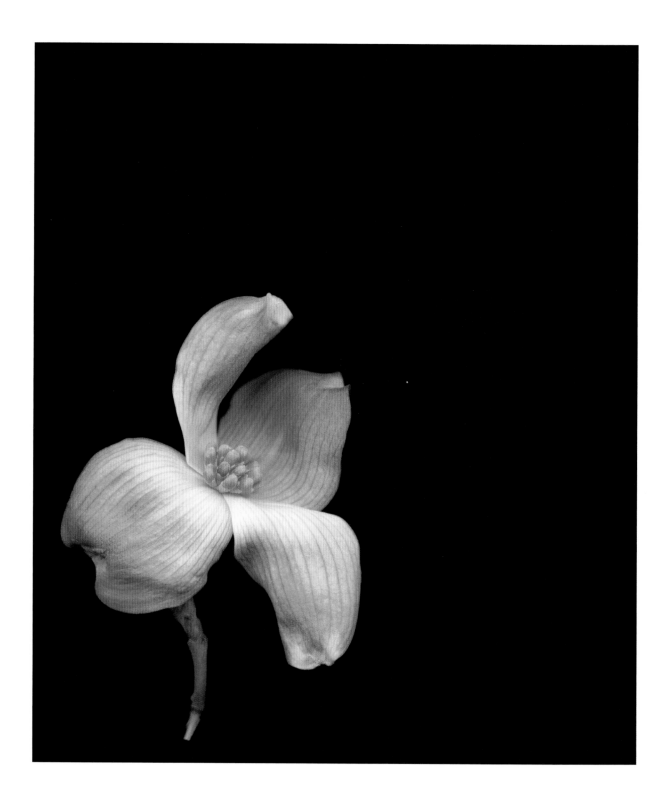

plate 7

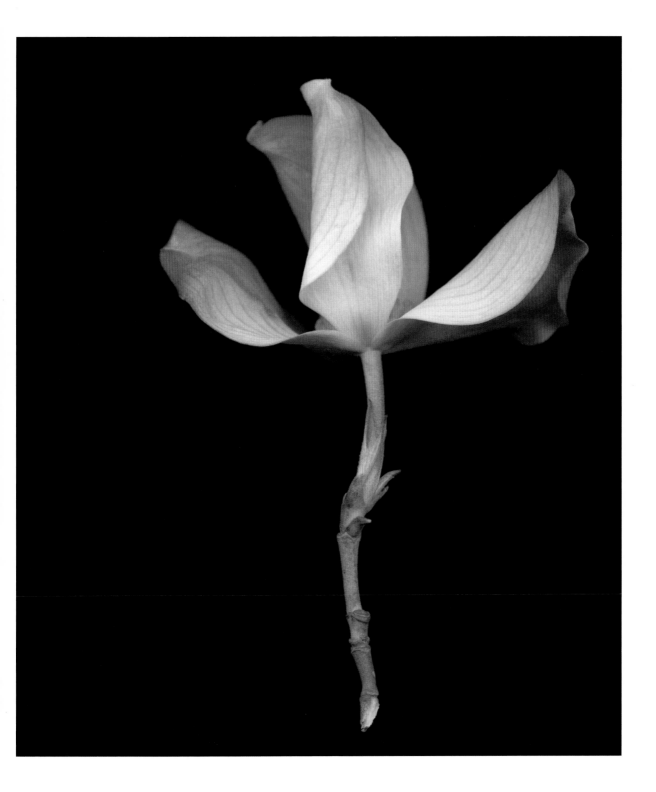

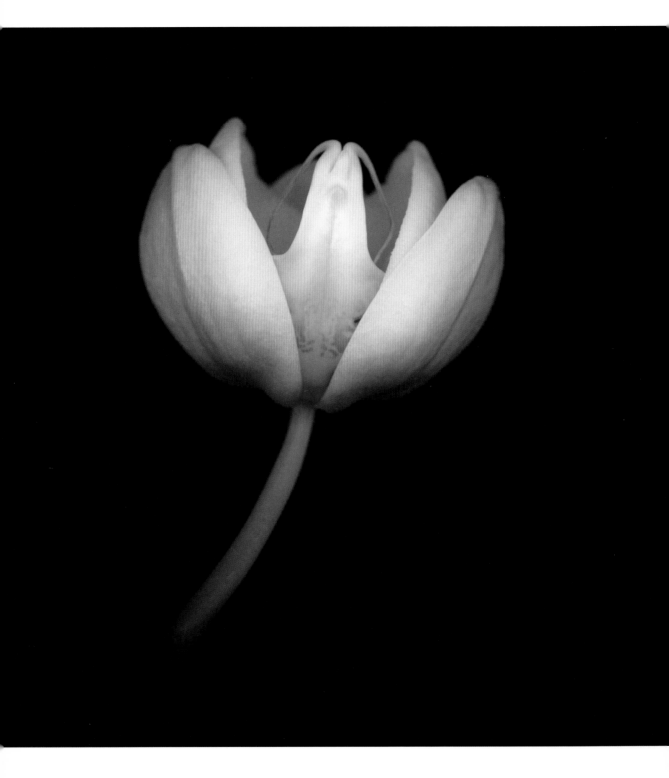

plate 8

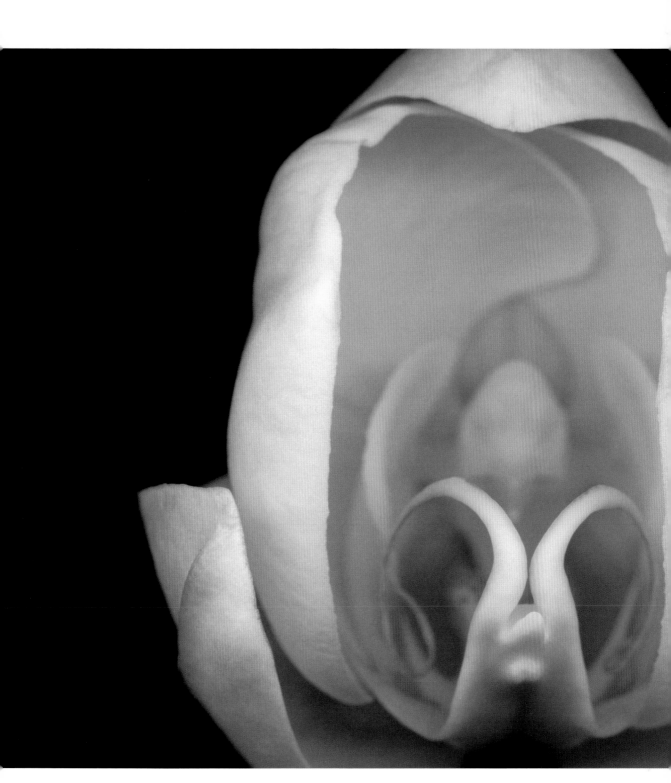

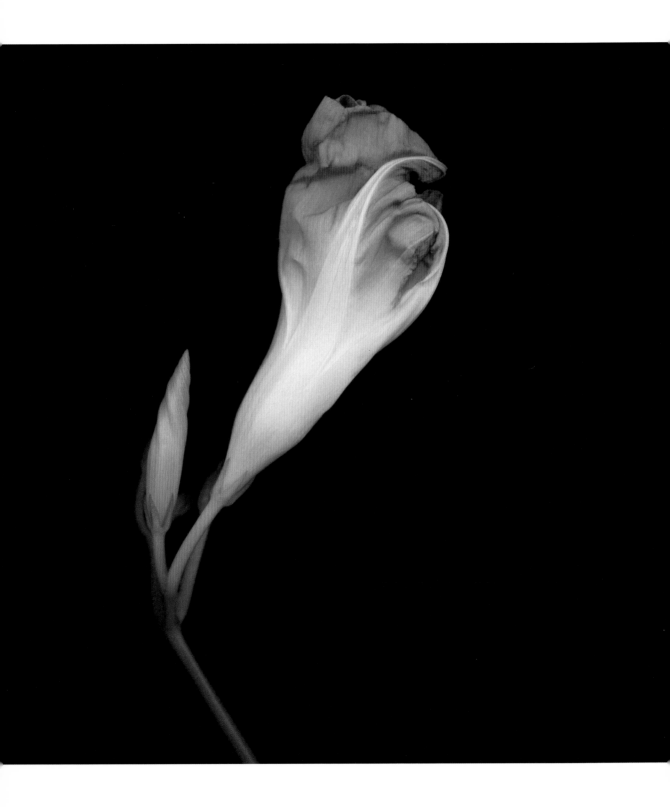

plate 9

And the day came when the risk to remain tight in a bud
was more painful than the risk it took to blossom.

ANAÏS NIN

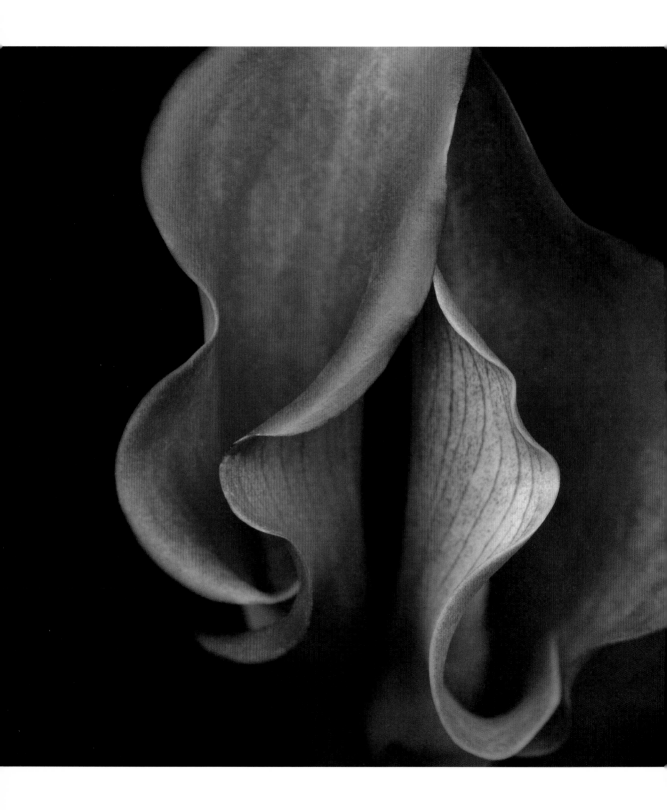

plate 10

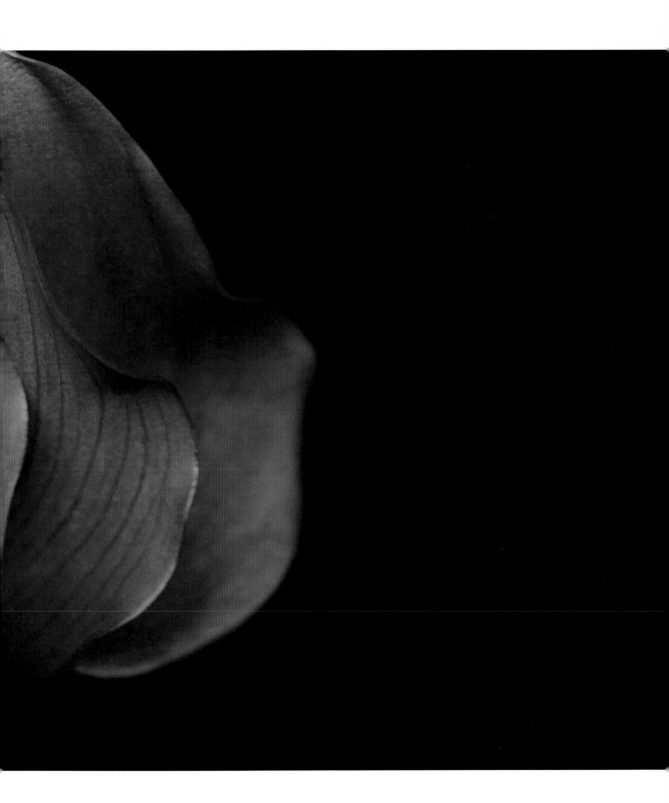

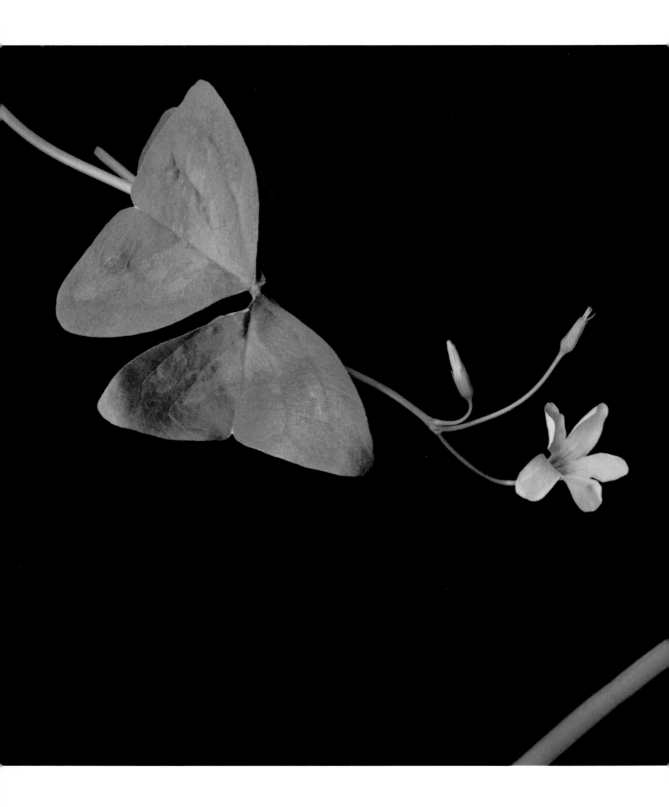

plate 11

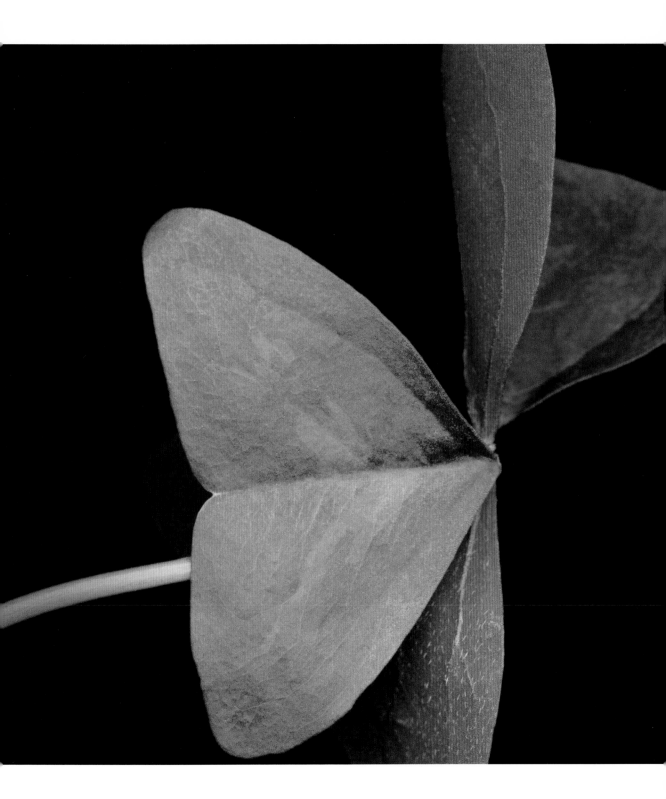

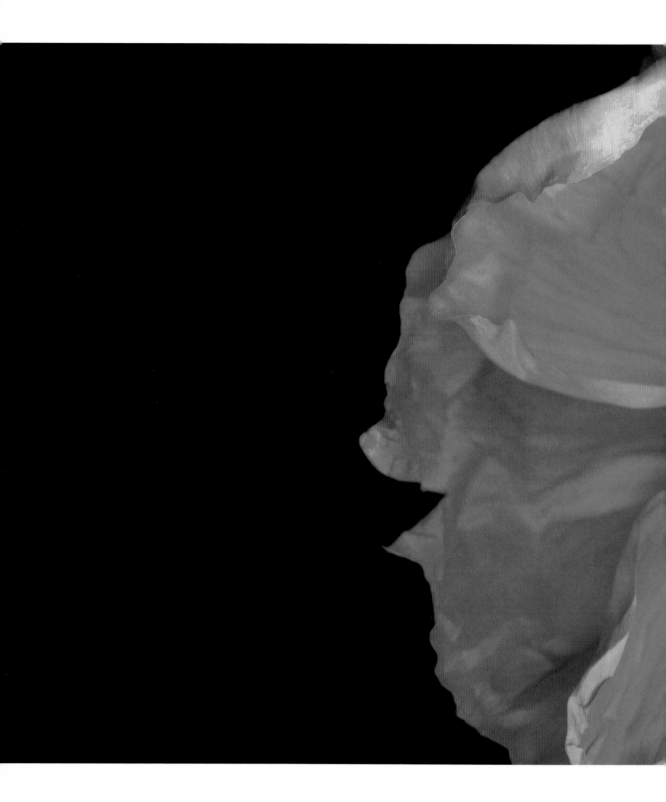

plate 12

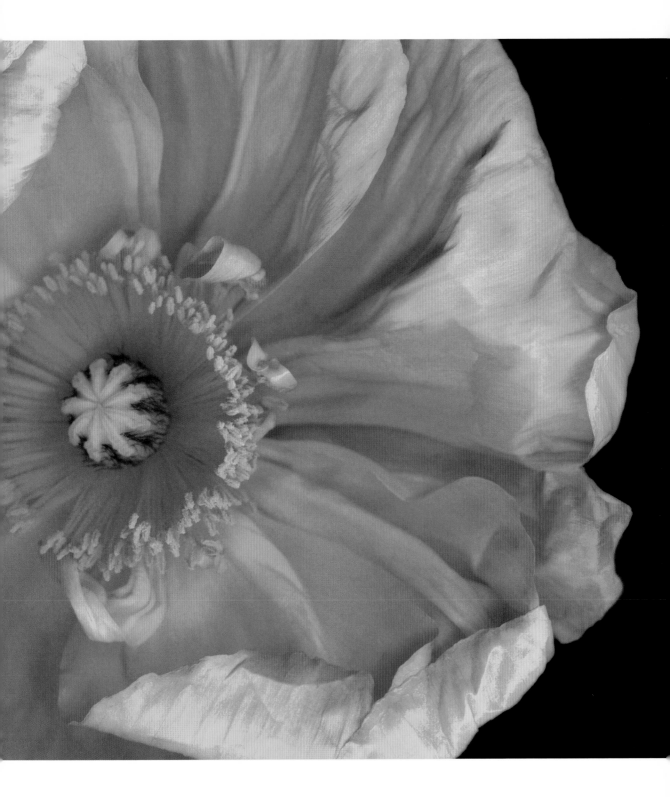

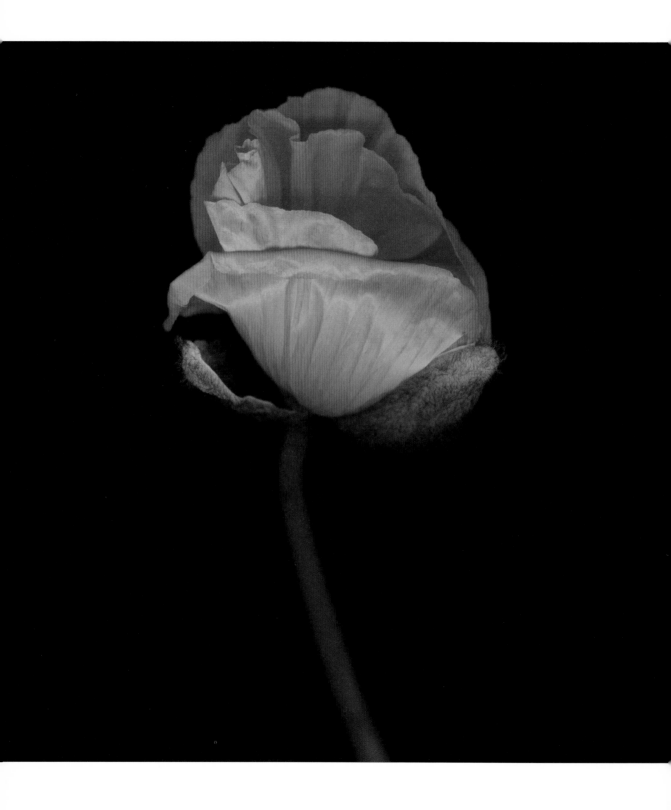

plate 13

Earth laughs in flowers.

RALPH WALDO EMERSON

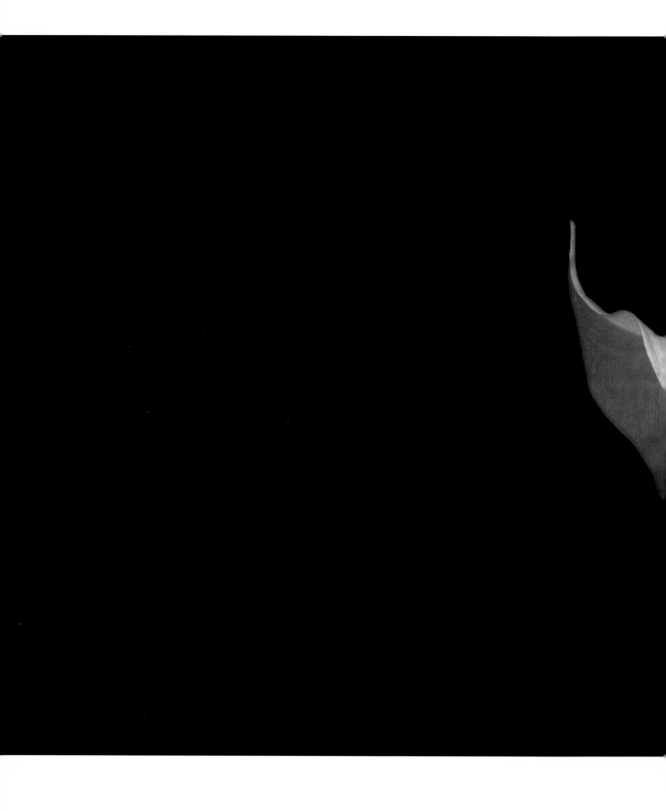

plate 14

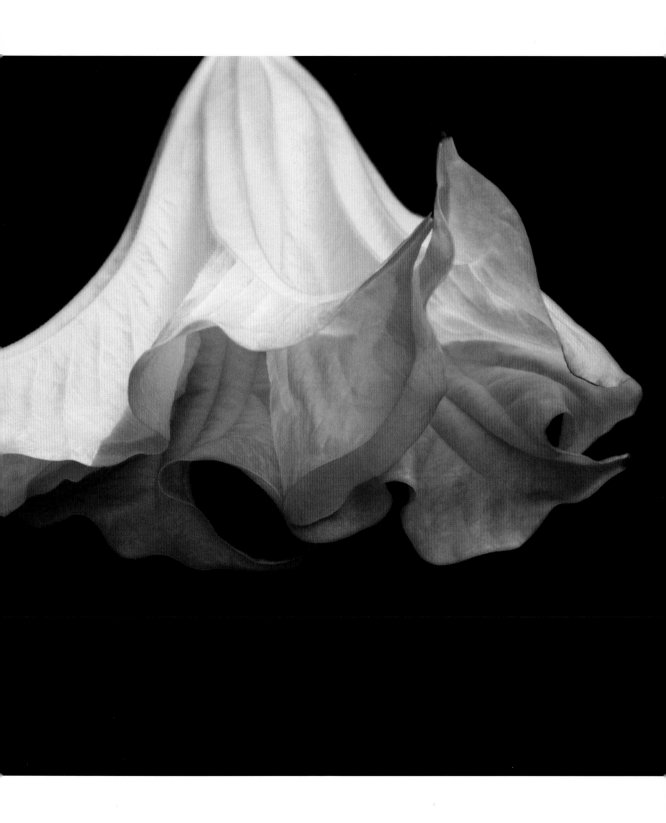

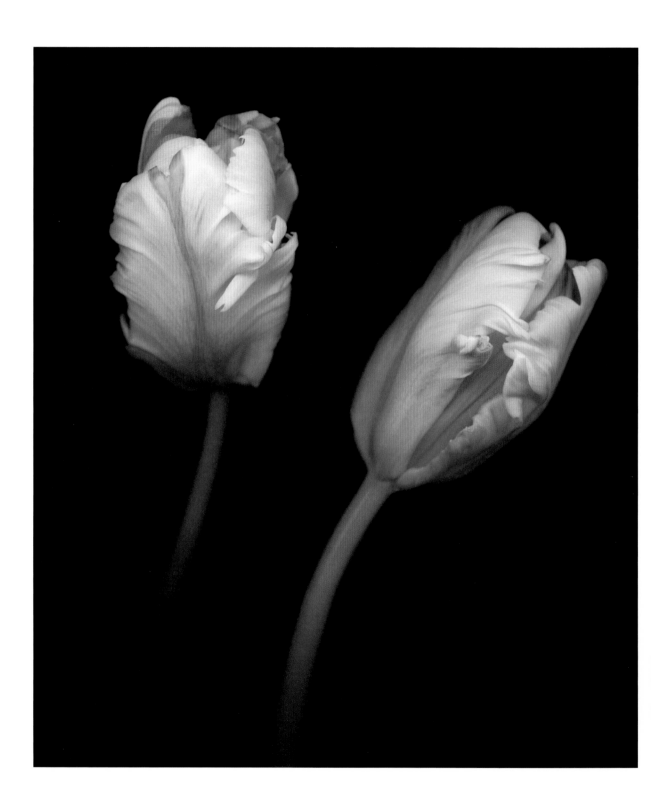

plate 15

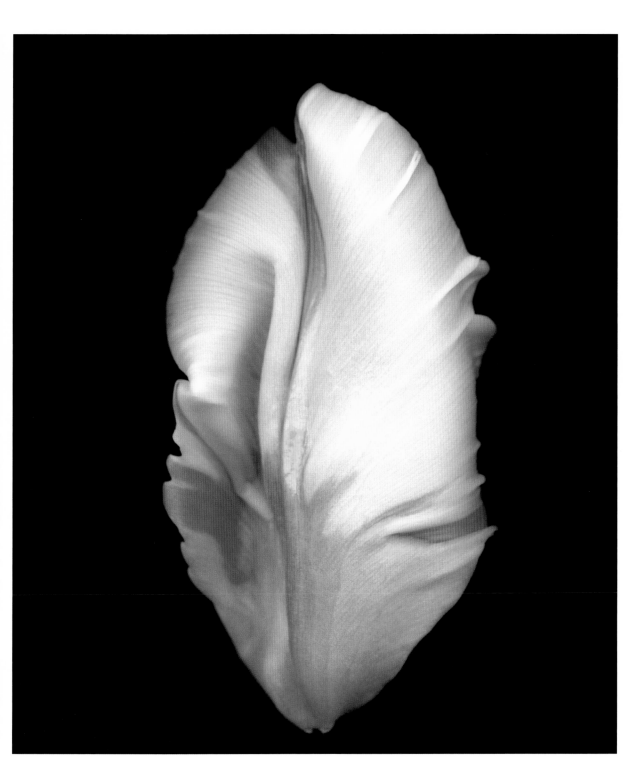

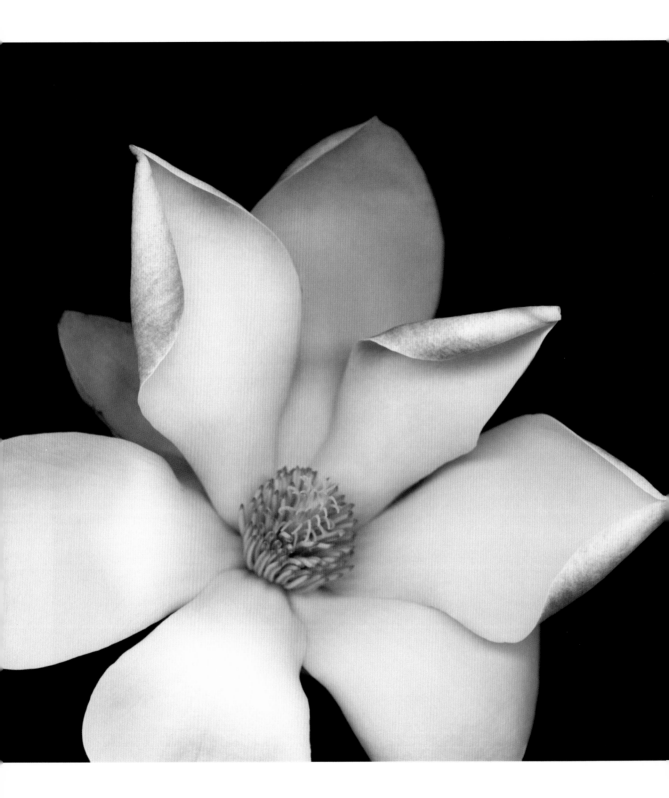

plate 16

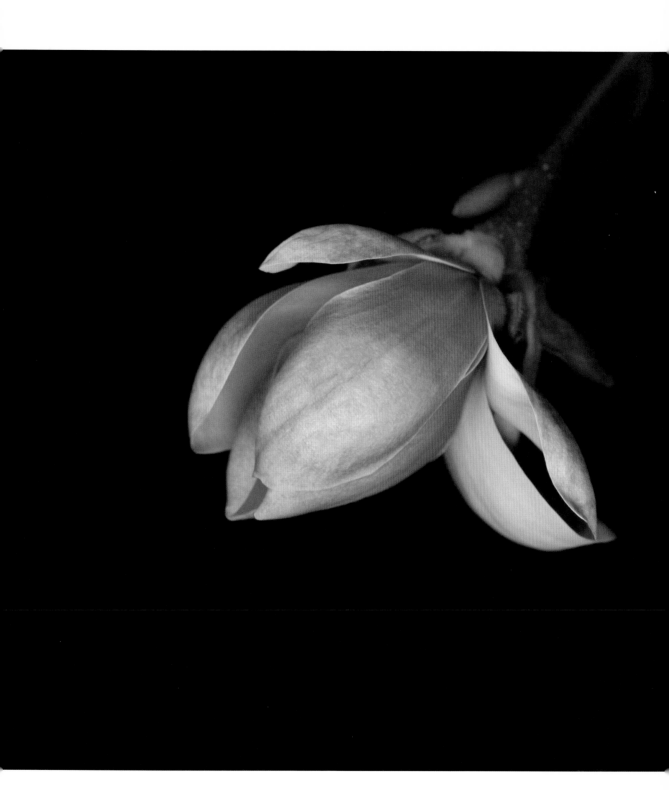

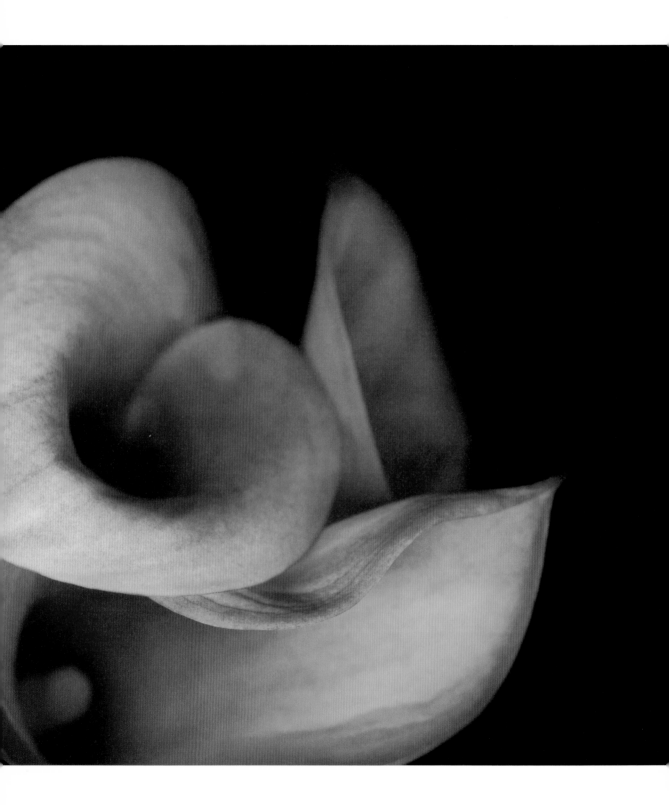

plate 17

The only journey is the one within.

RAINER MARIA RILKE

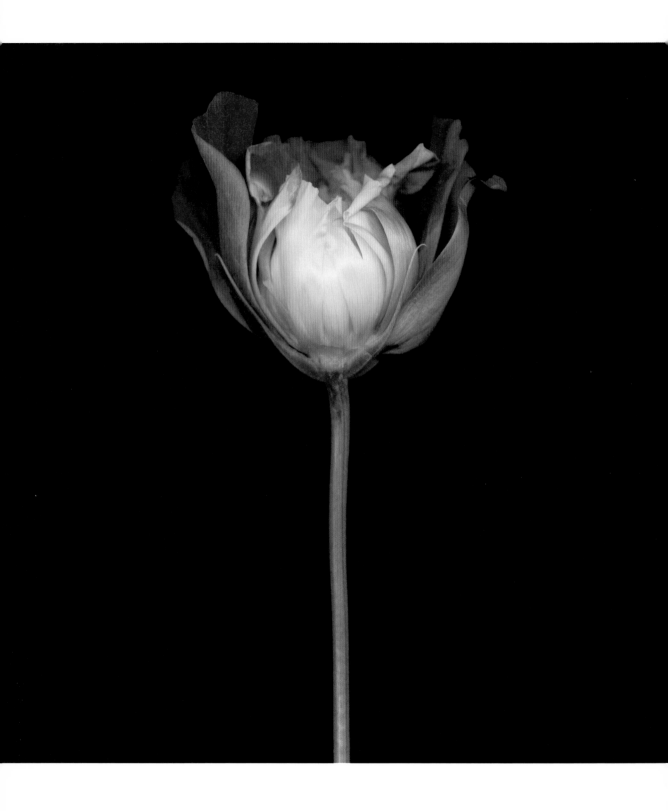

plate 18

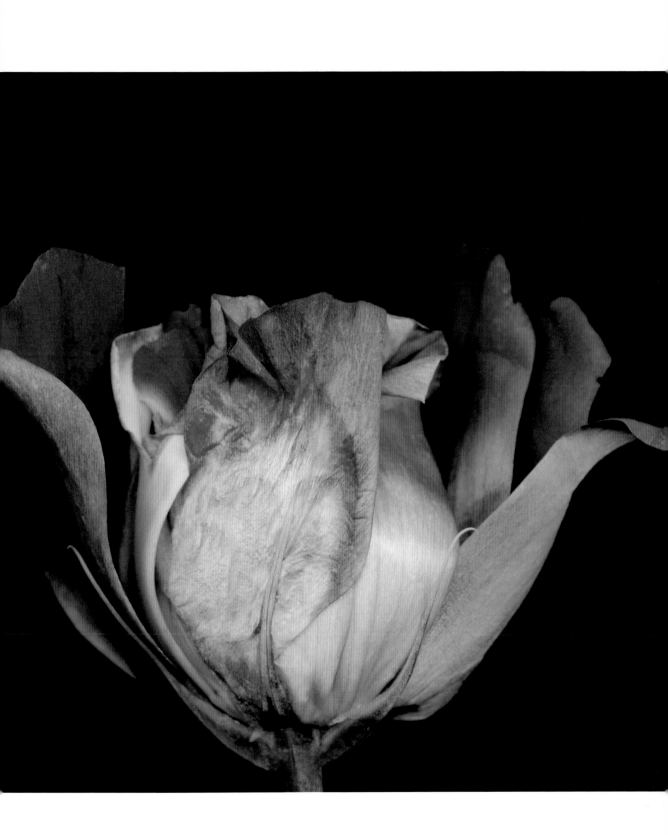

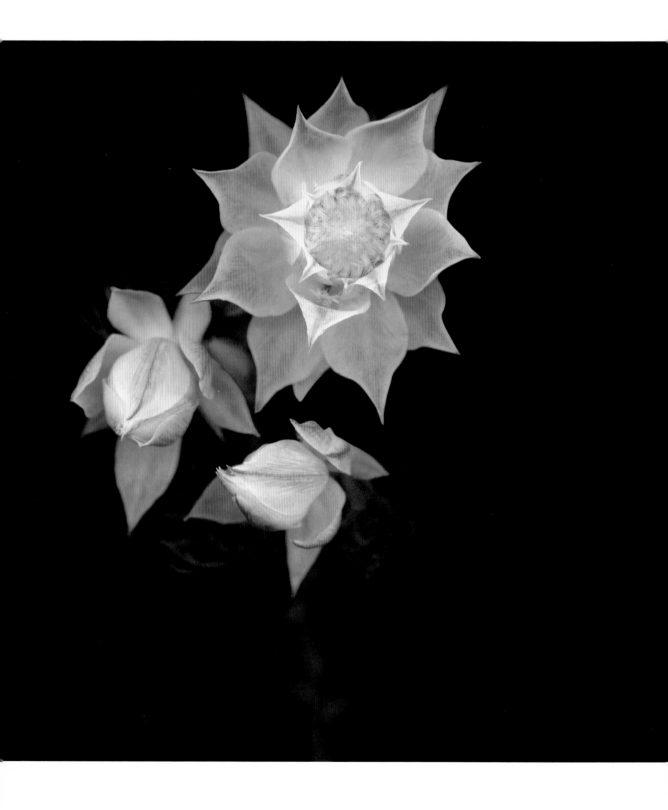

plate 19

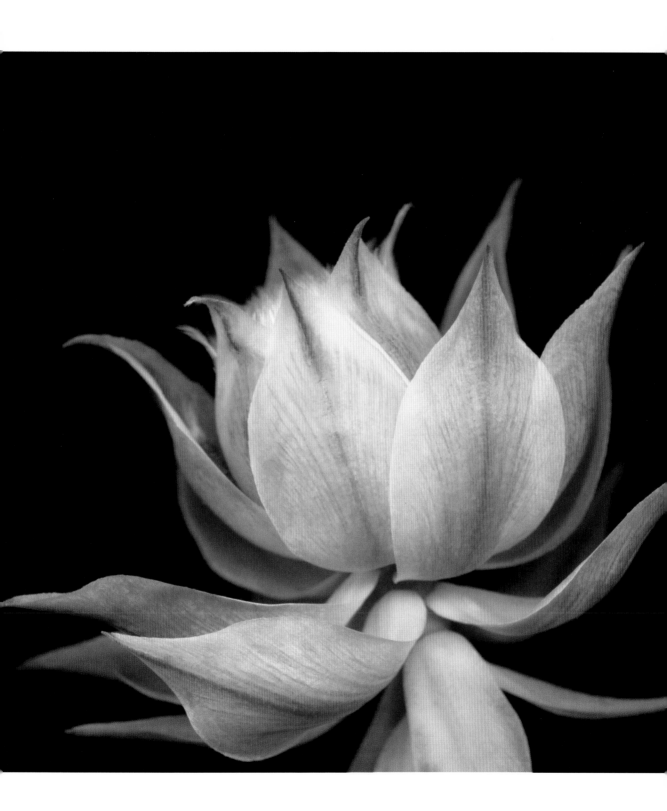

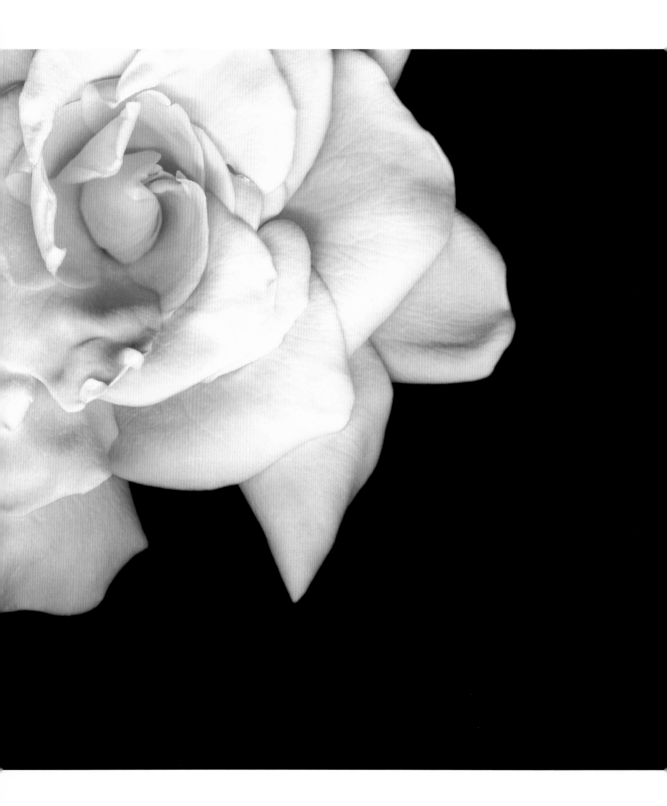

plate 20

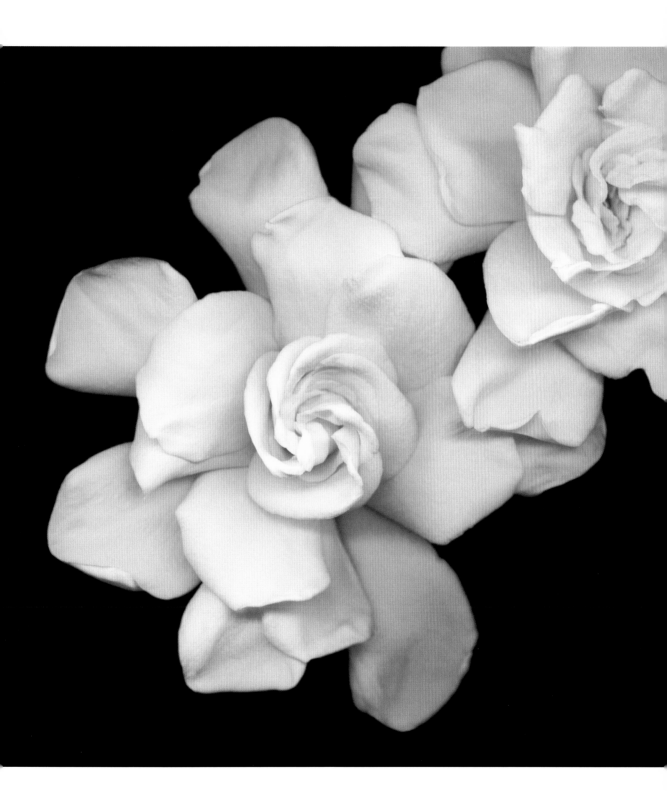

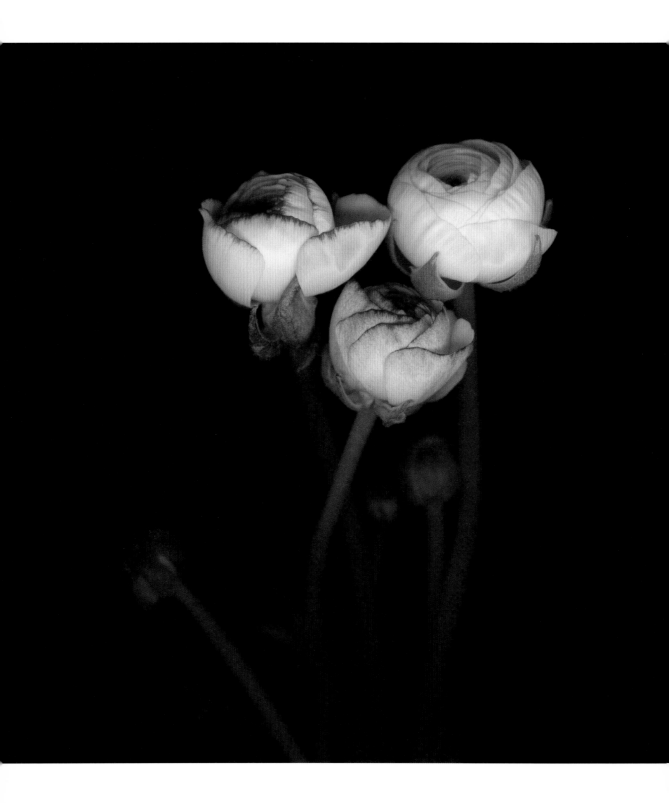

plate 21

Achieve your own beauty, as the flowers do.

D.H. LAWRENCE

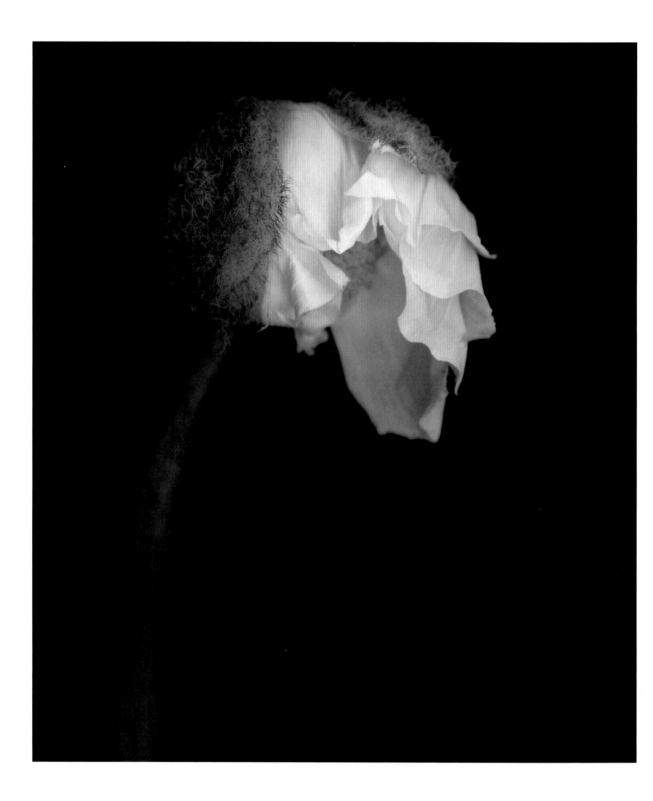

plate 22

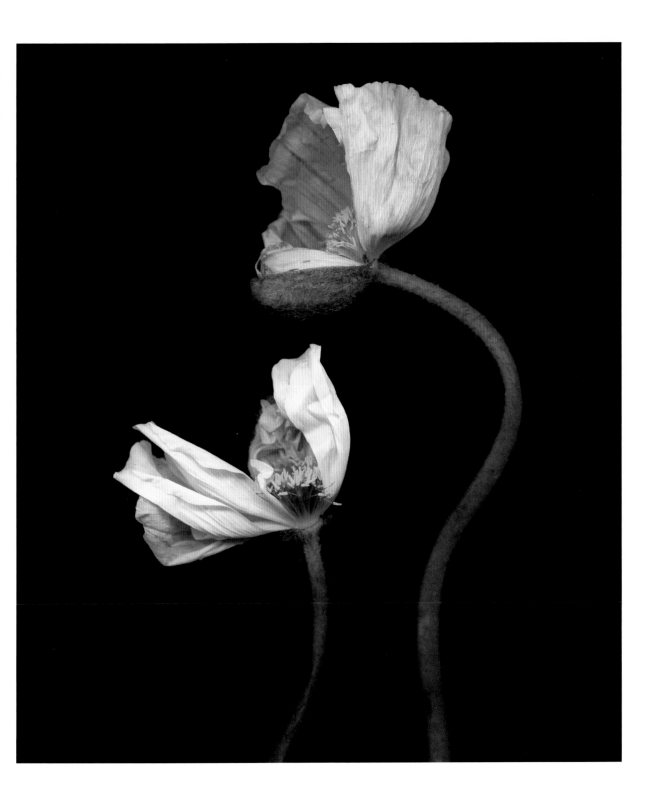

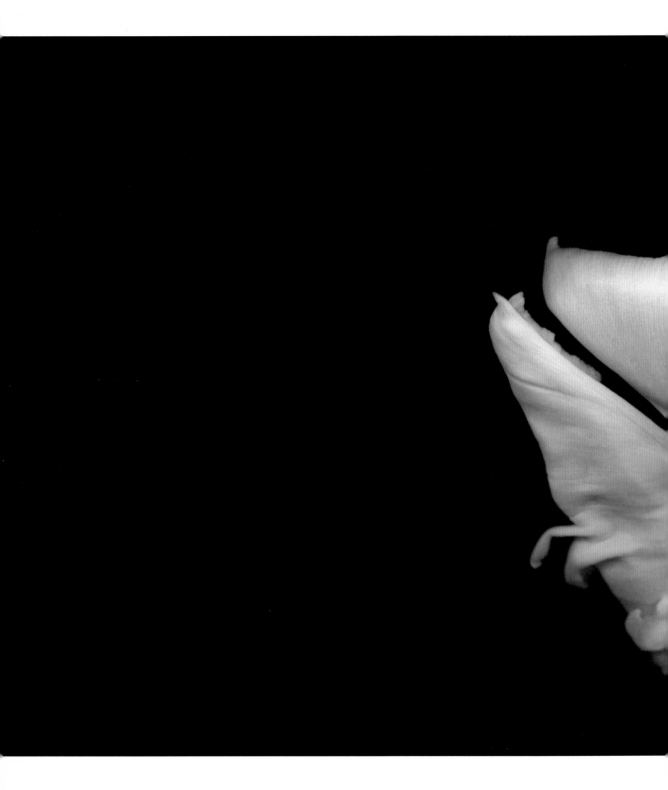

plate 23

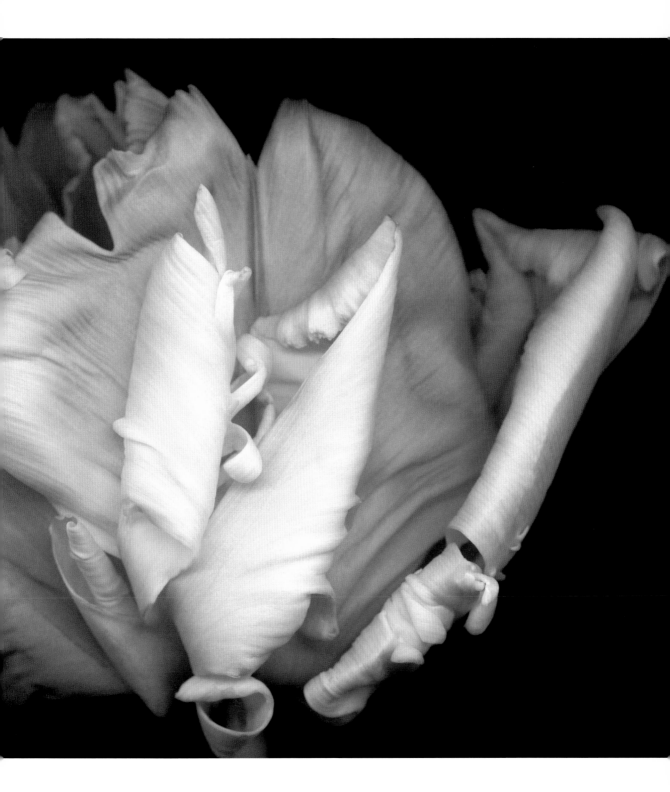

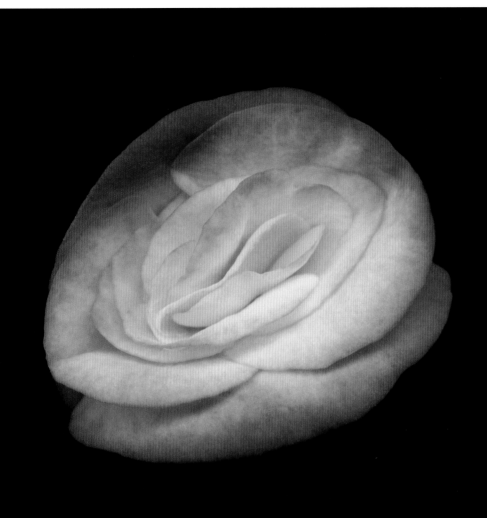

plate 24

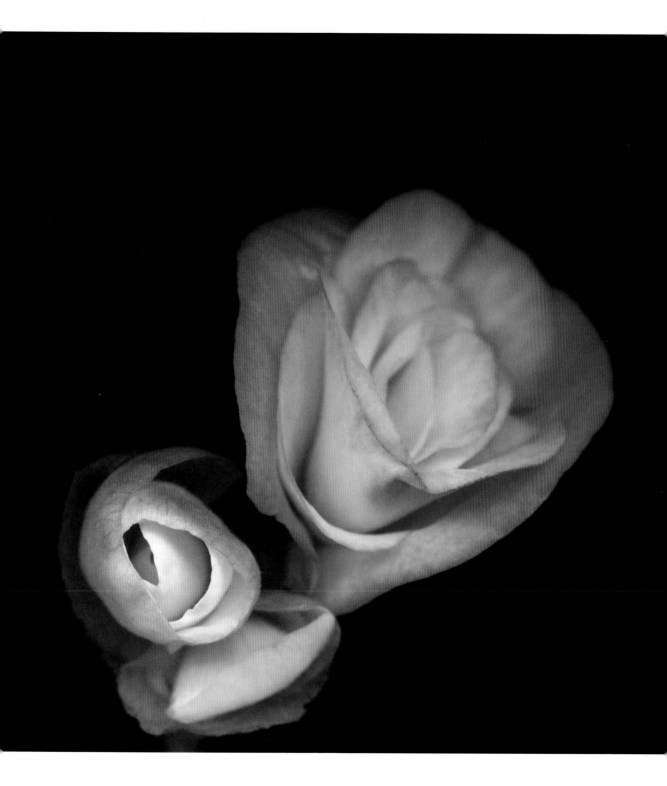

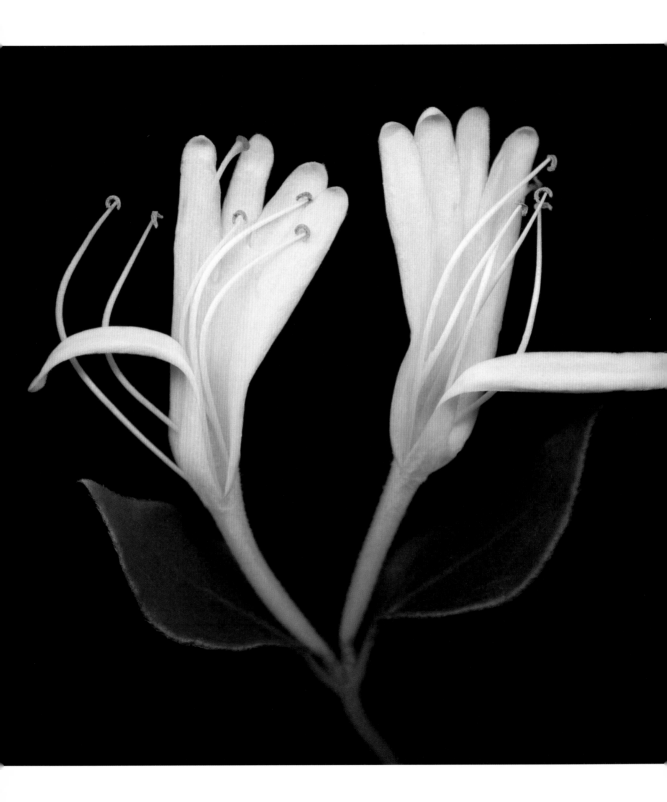

plate 25

Flowers leave some of their fragrance in the hand that bestows them.

CHINESE PROVERB

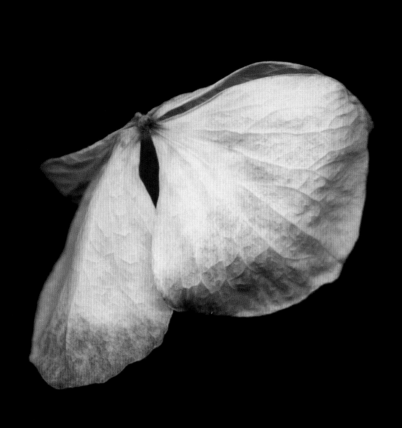

plate 26

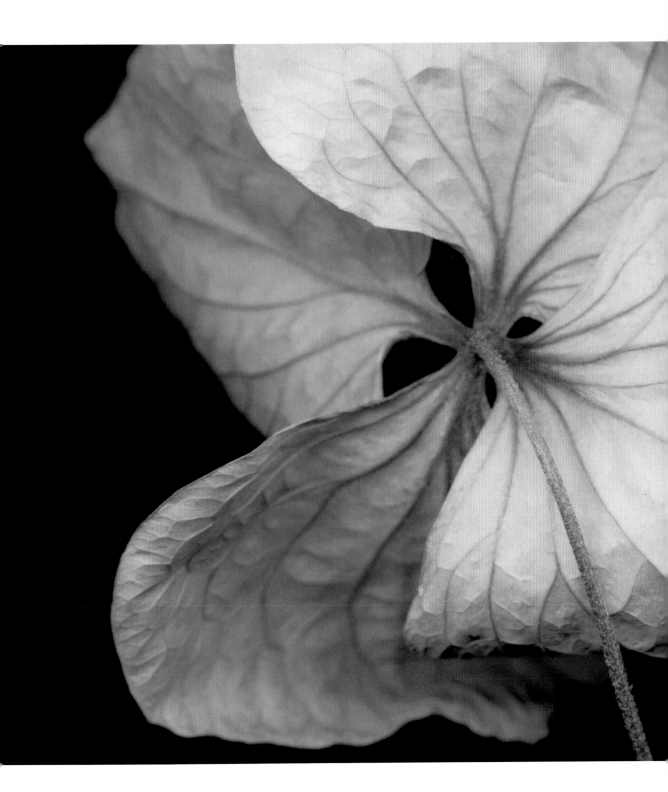

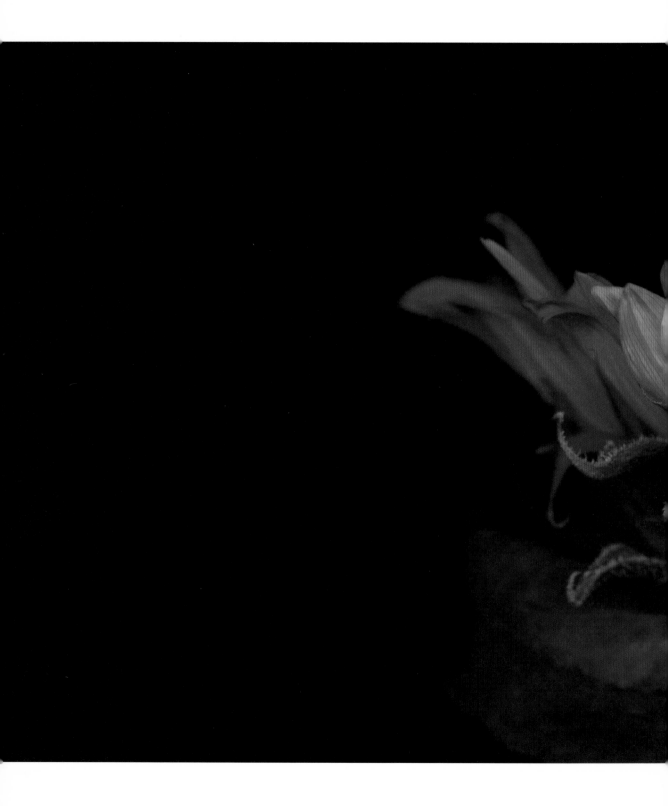

plate 27

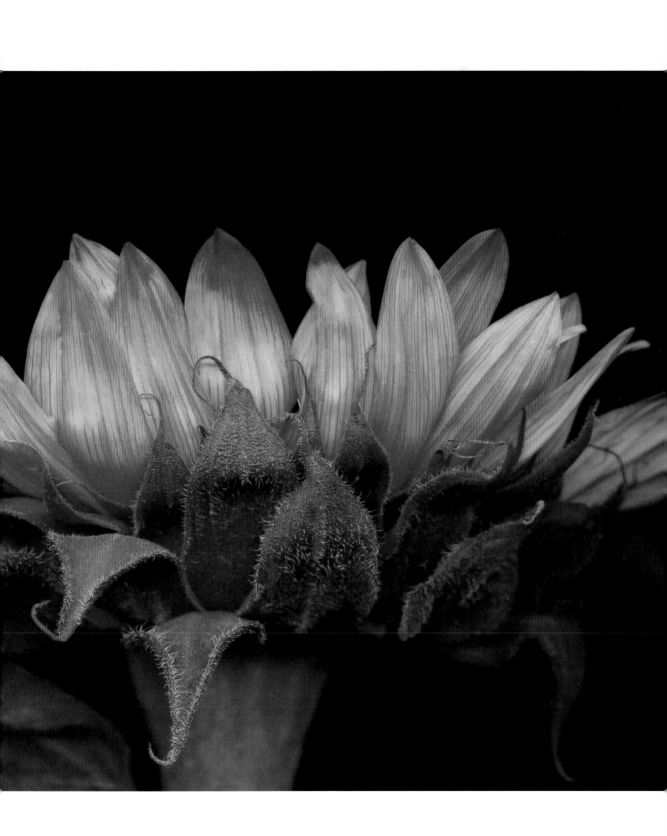

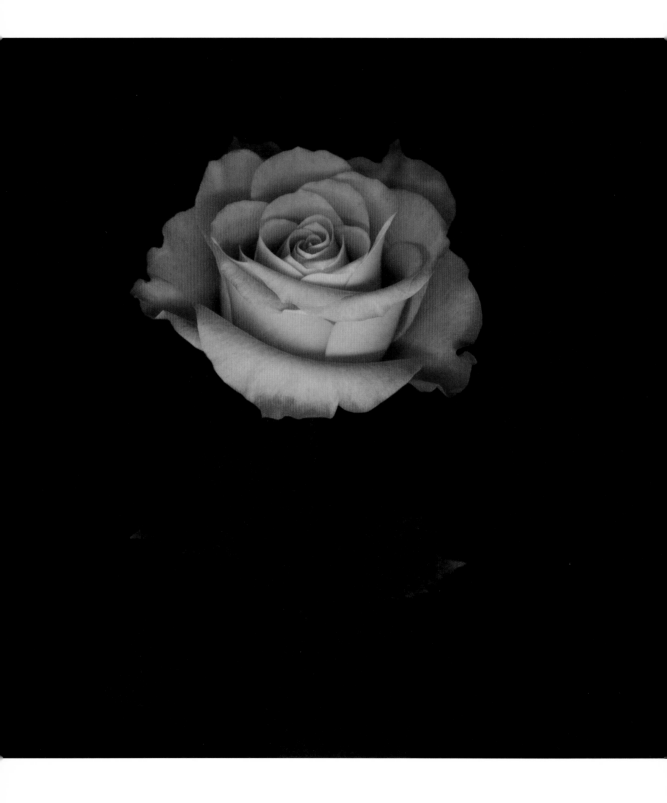

plate 28

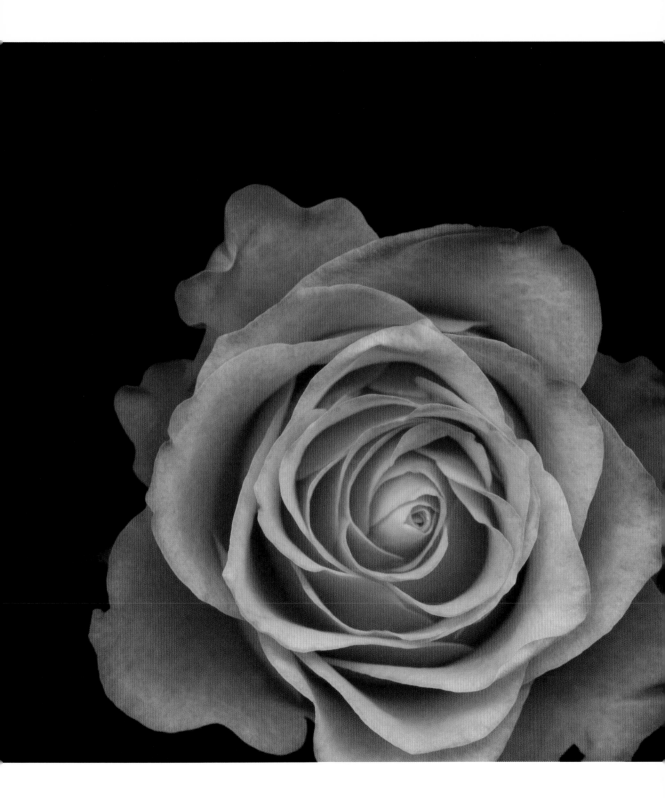

The temple bell stops–
but the sound keeps coming
out of the flowers.
Matsuo Basho

plate 29

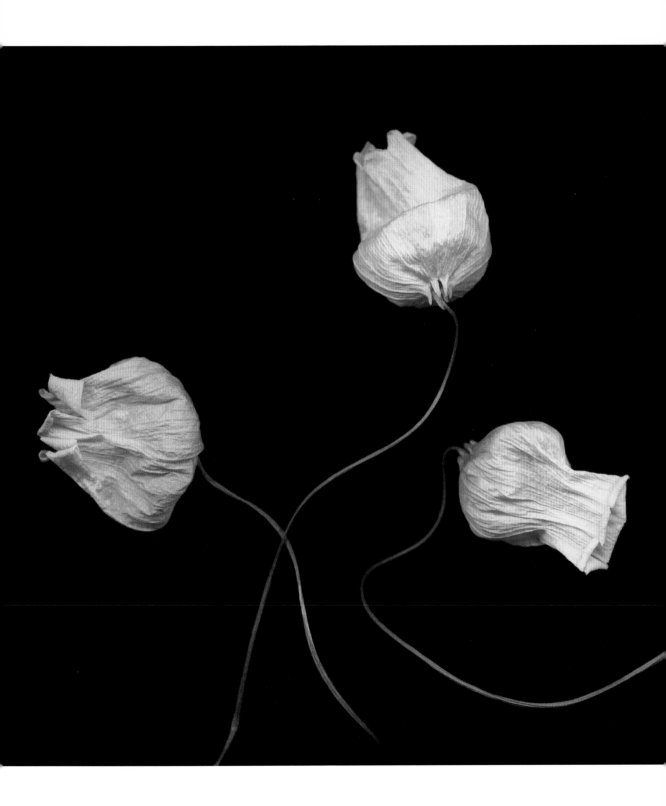

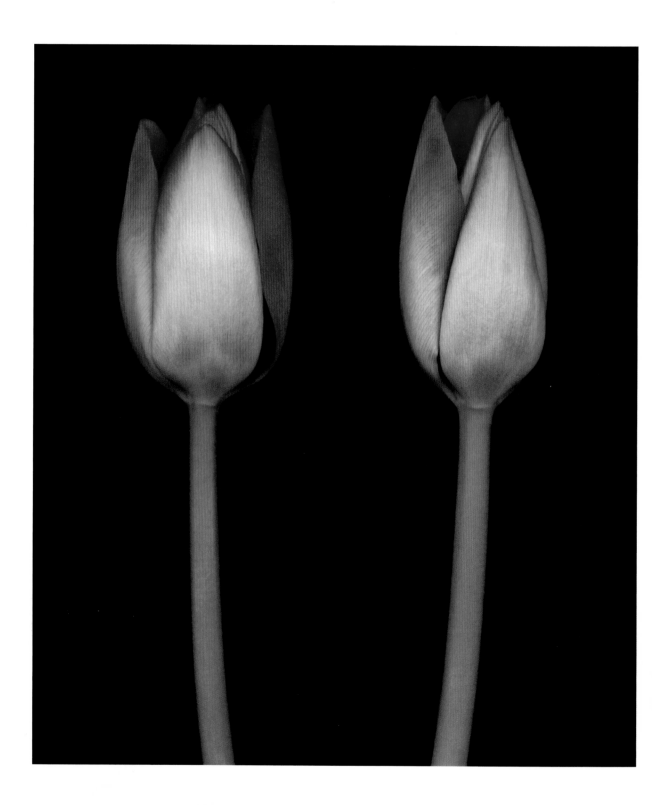

plate 30

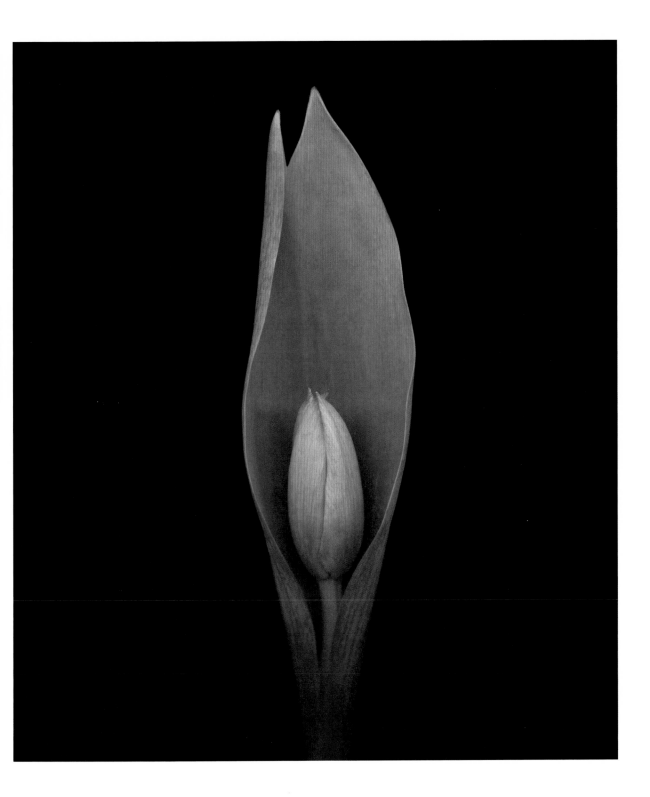

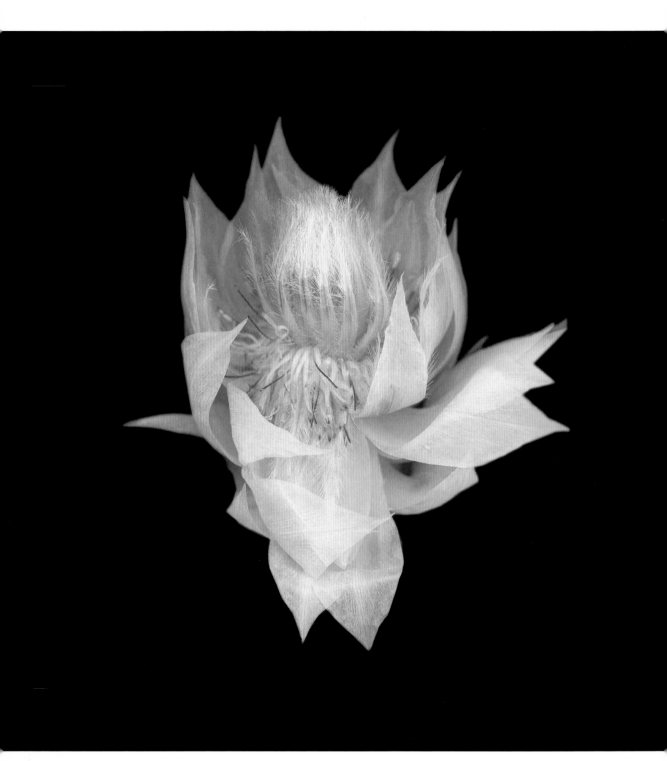

plate 31

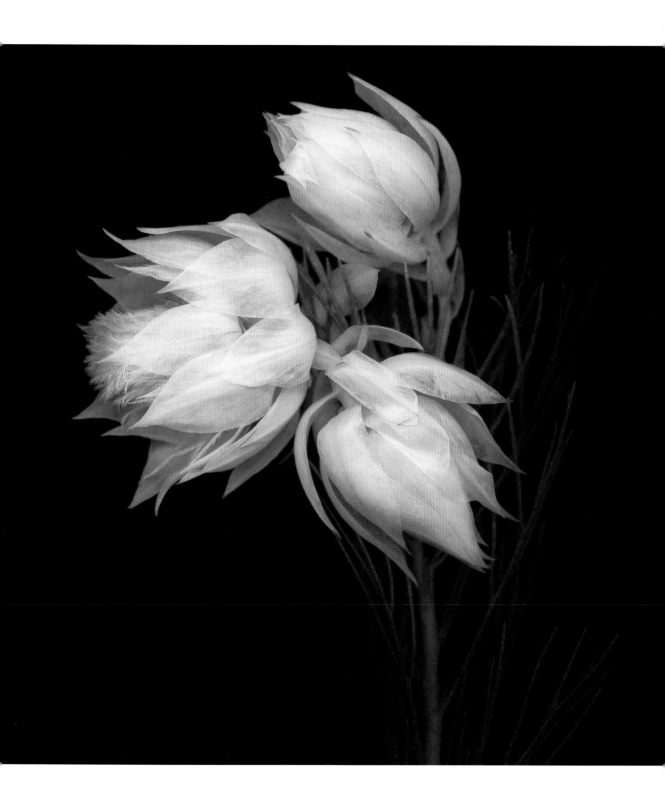

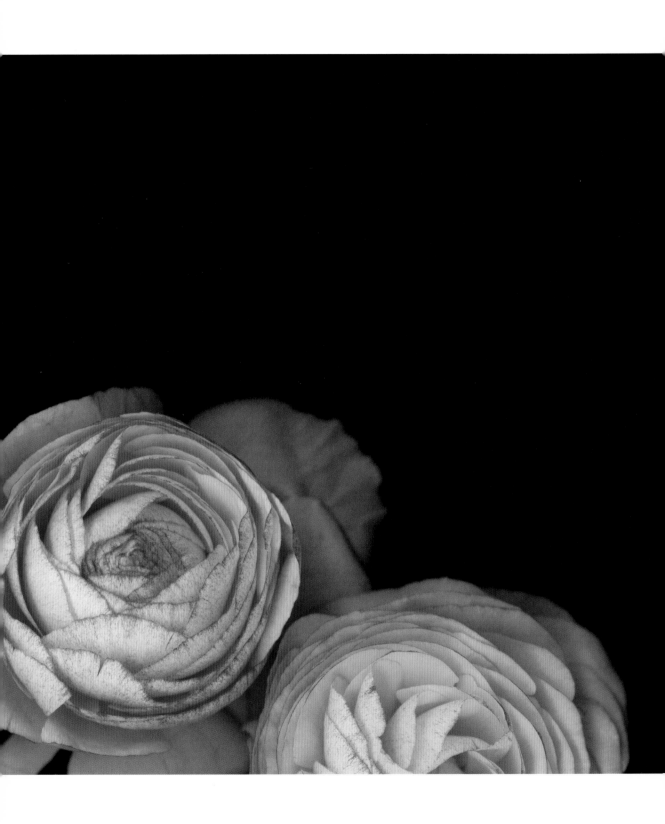

plate 32

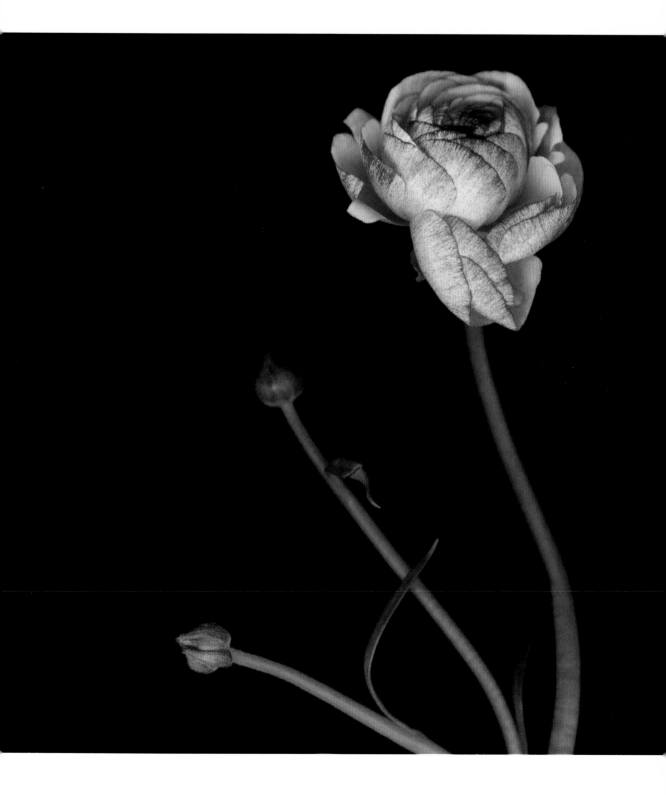

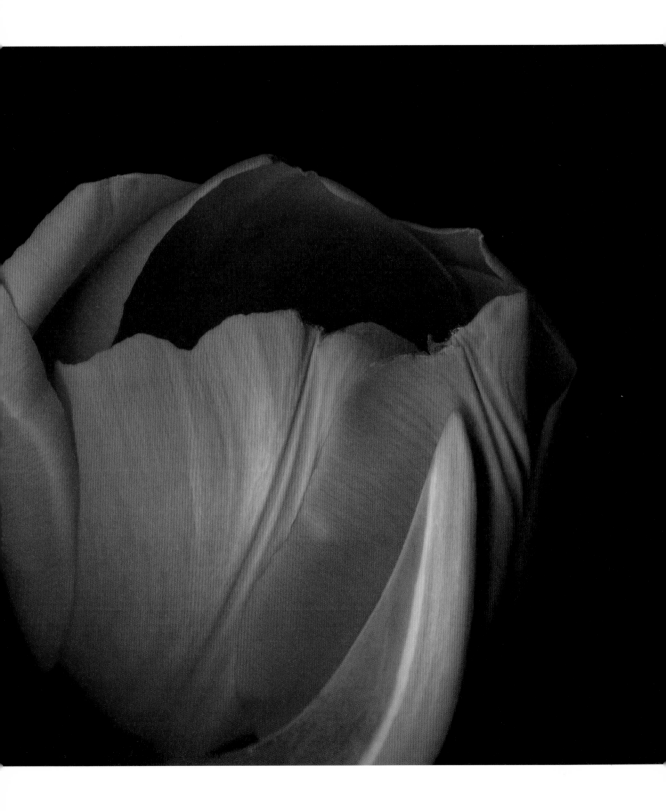

plate 33

Not knowing when the dawn will come
I open every door.

EMILY DICKINSON

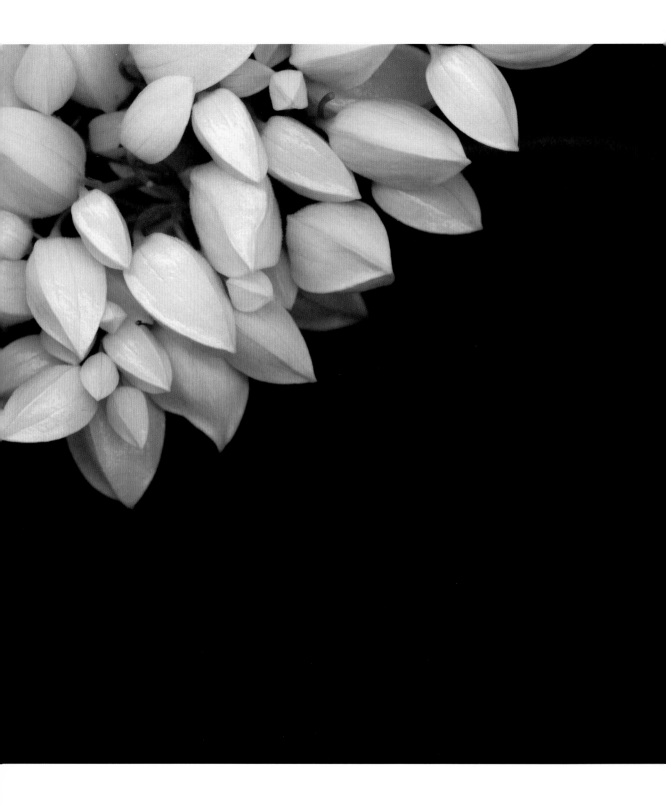

plate 34

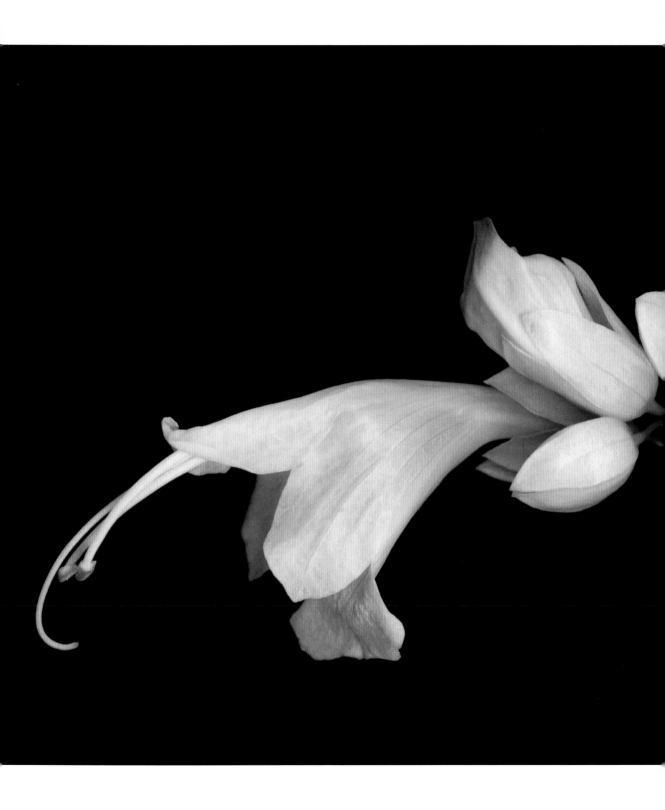

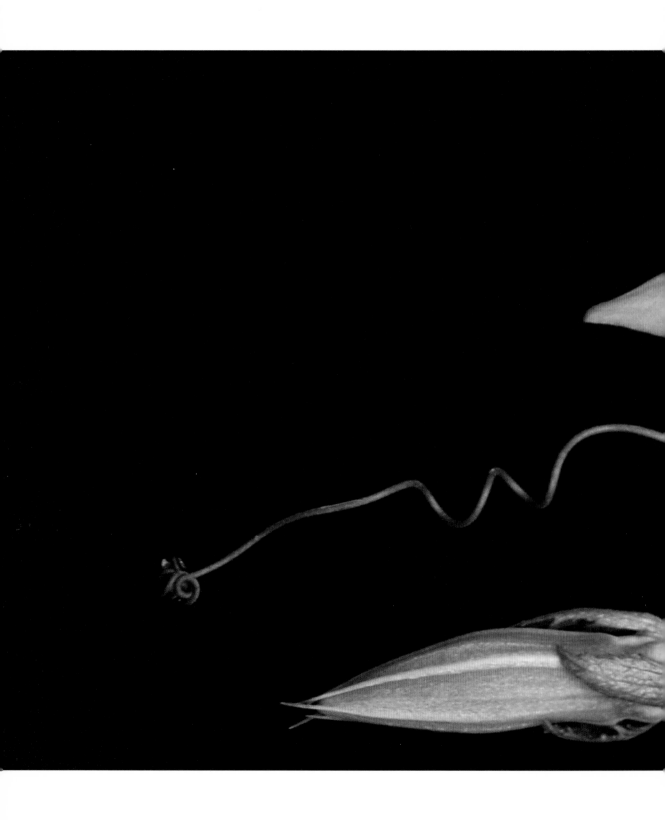

plate 35

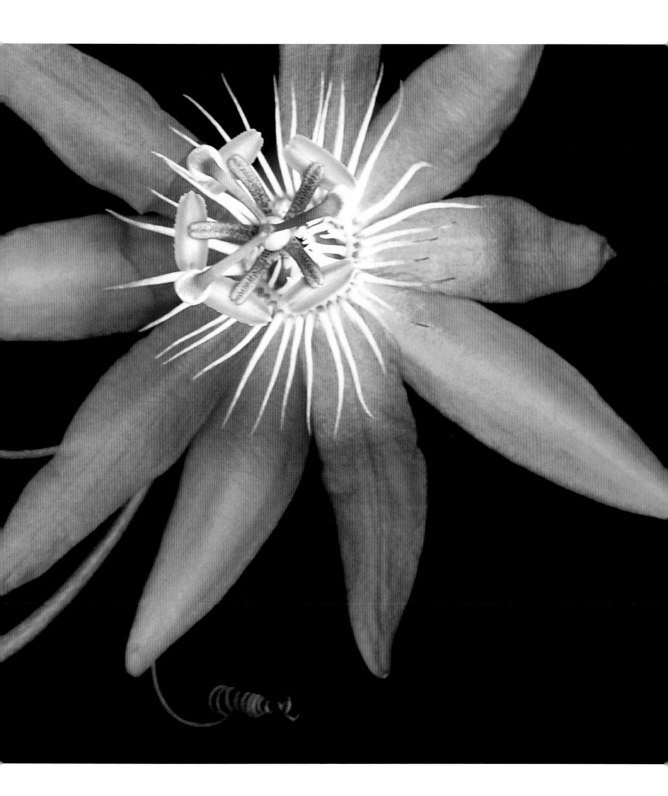

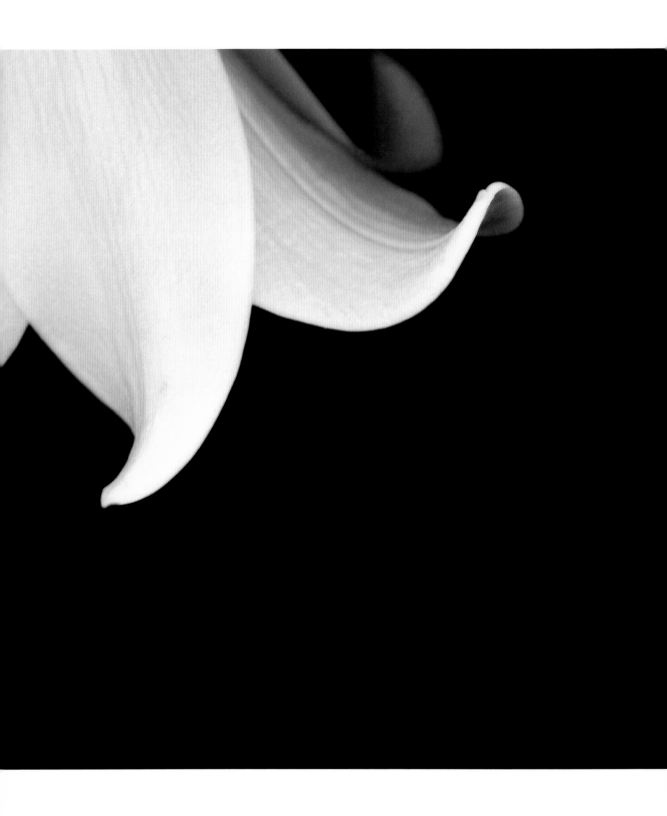

plate 36

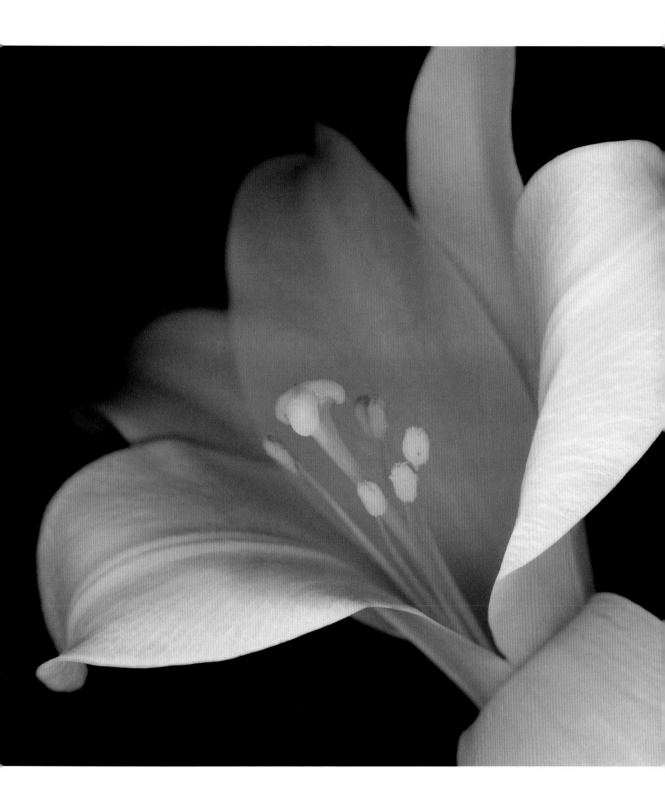

Every flower holds the whole mystery in its short cycle…

MAY SARTON

plate 37

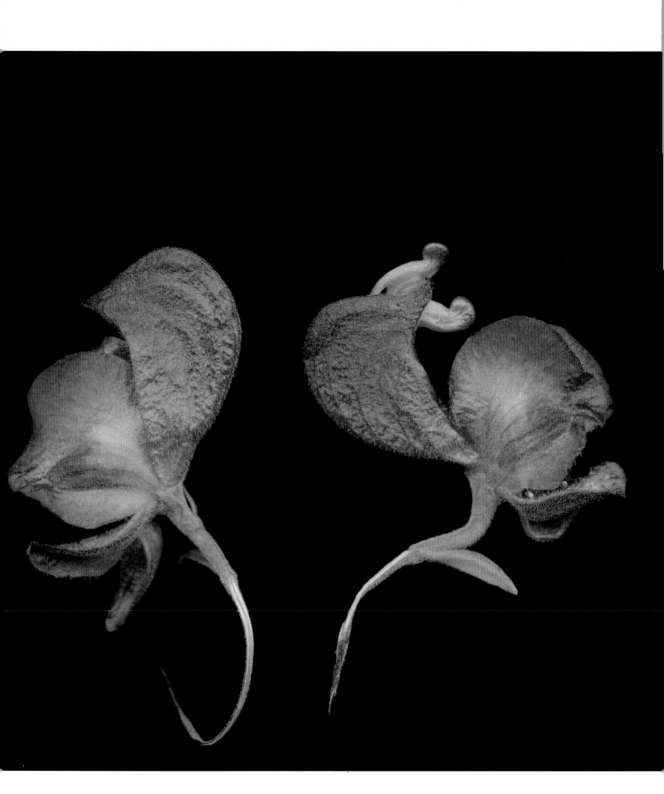

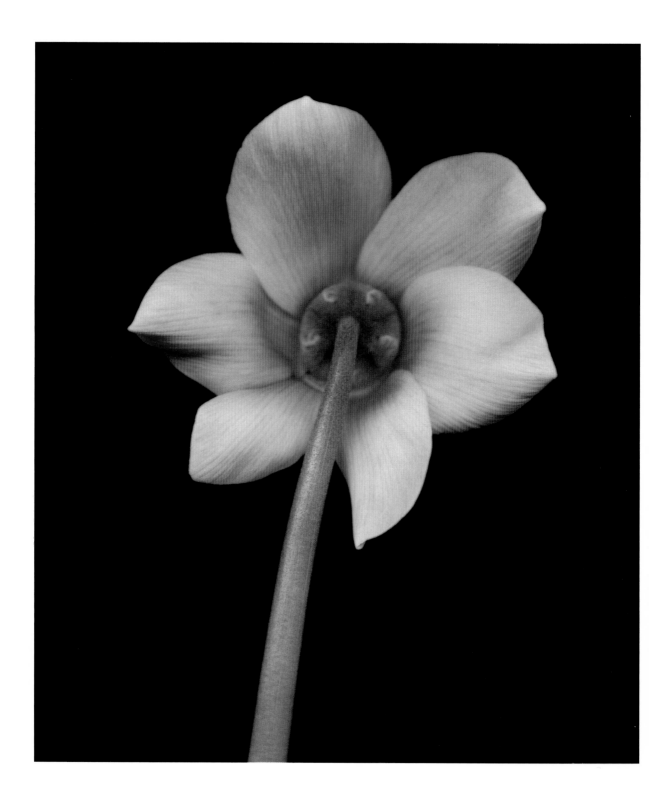

plate 38

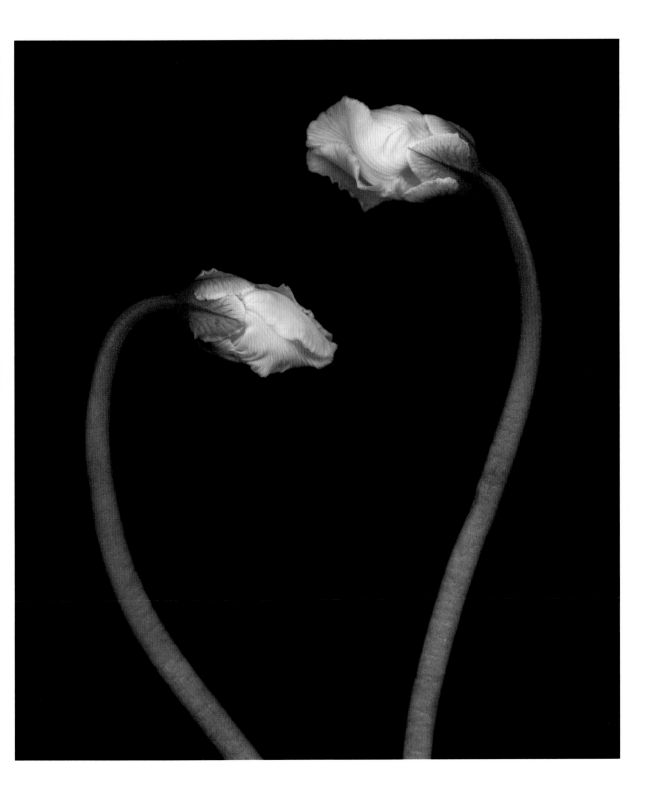

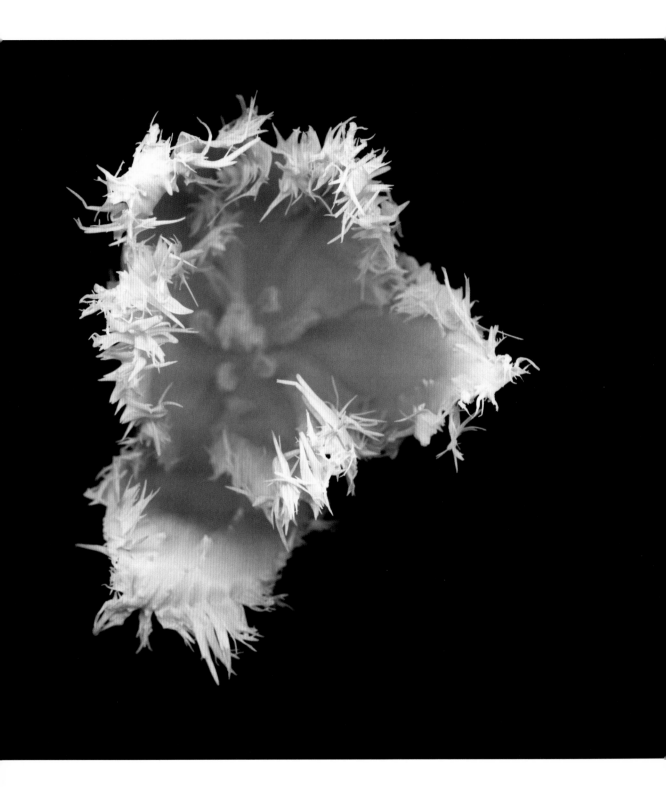

plate 39

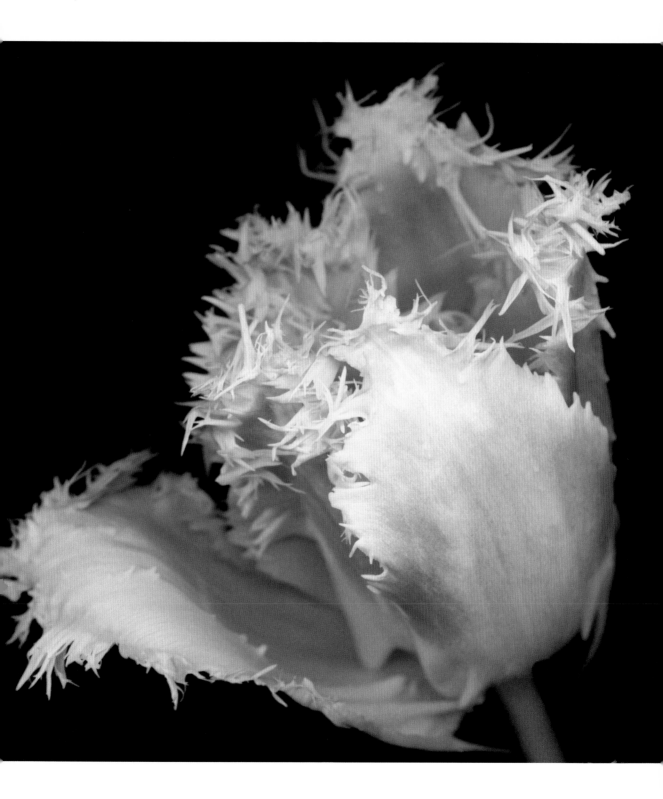

Those who dwell...among the beauties and mysteries
of the earth are never alone or weary of life.

<div align="right">RACHEL CARSON</div>

plate 40

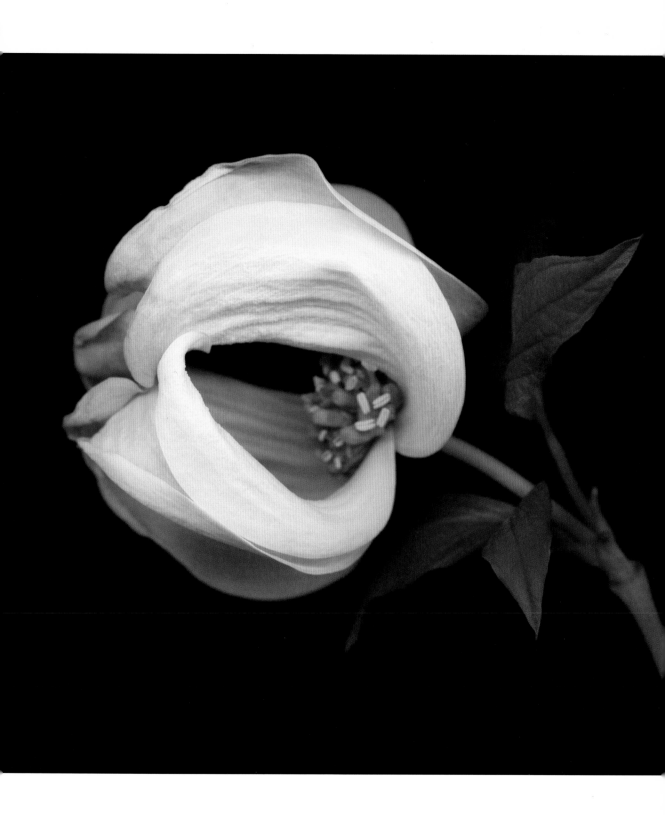

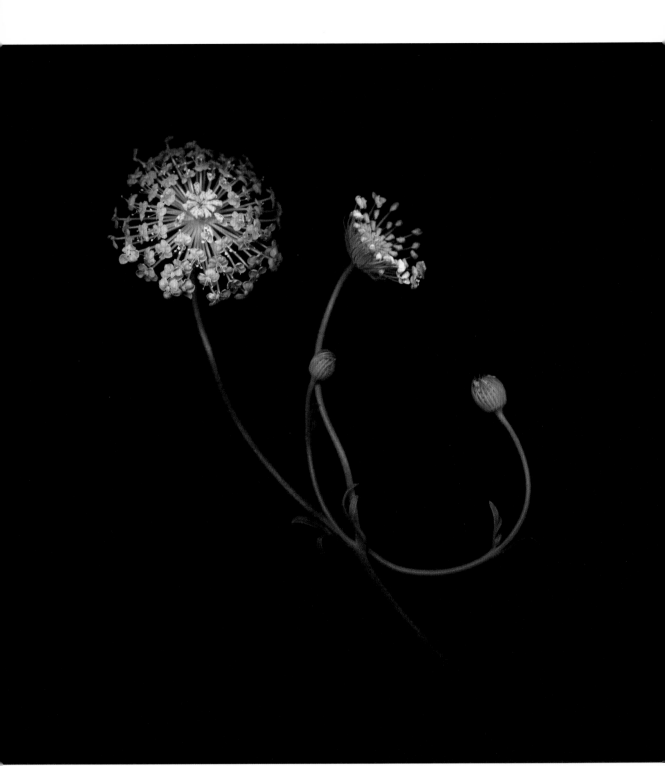

plate 41

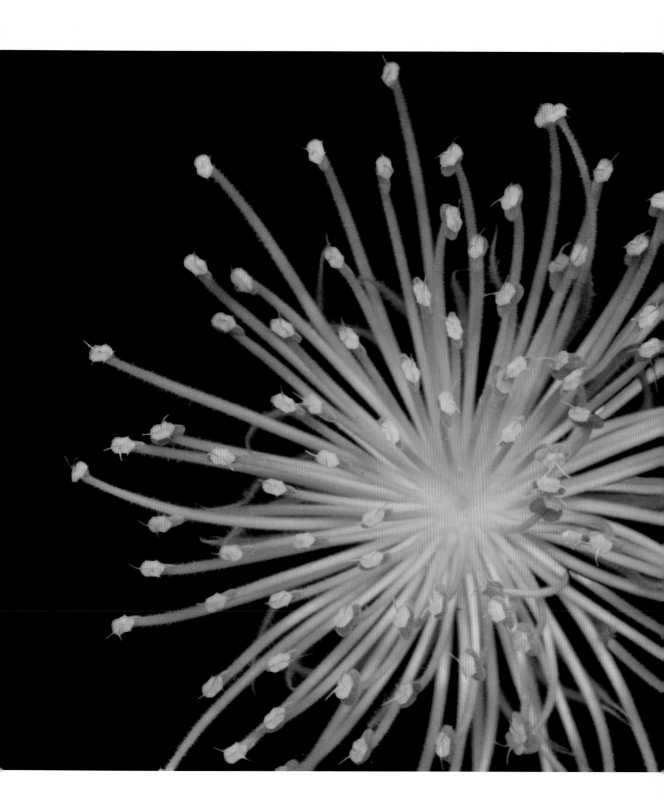

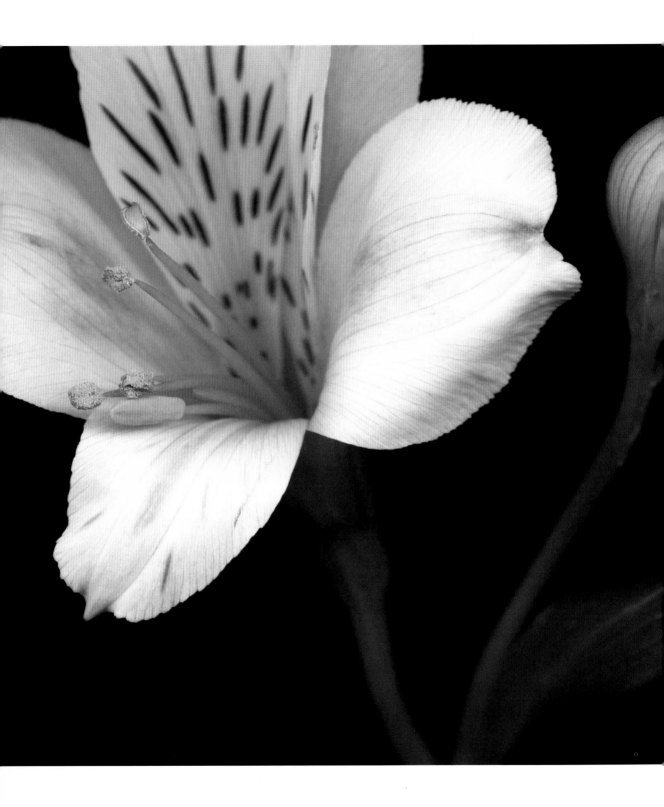

plate 42

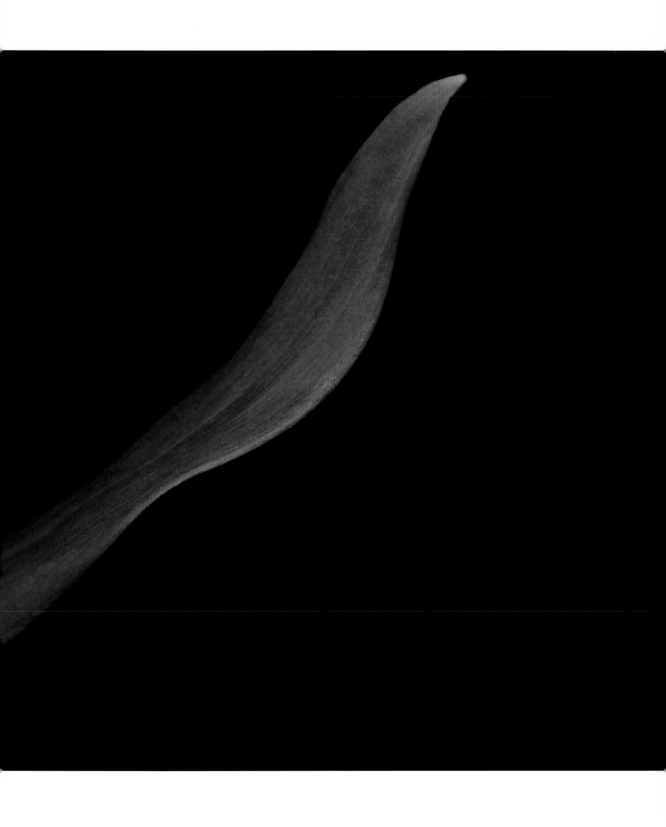

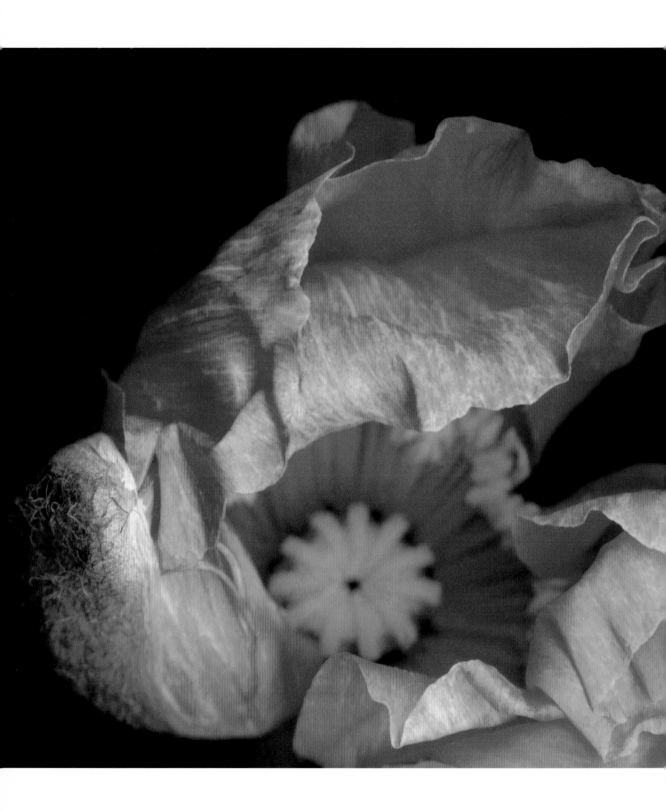

plate 43

All the flowers of all the tomorrows are in the seeds of today.

<div align="right">INDIAN PROVERB</div>

plate 44

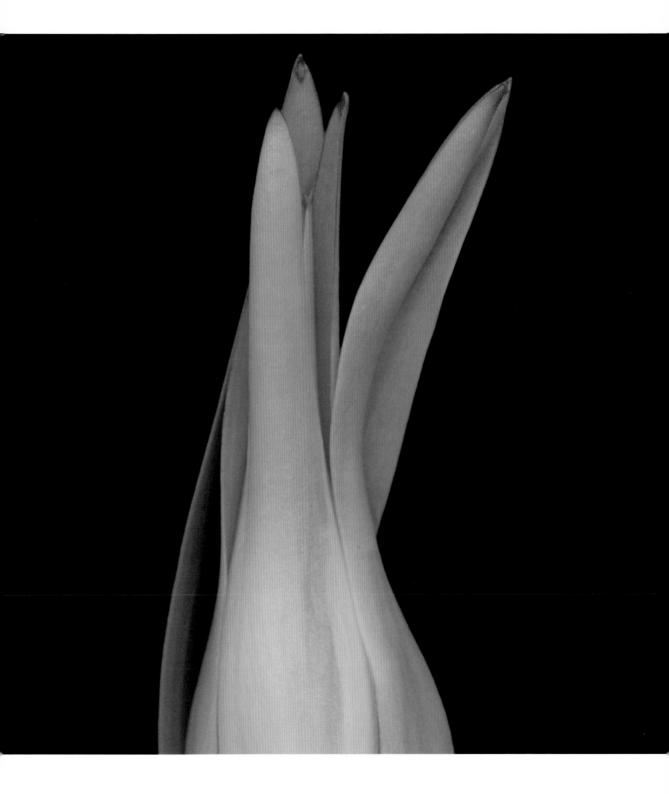

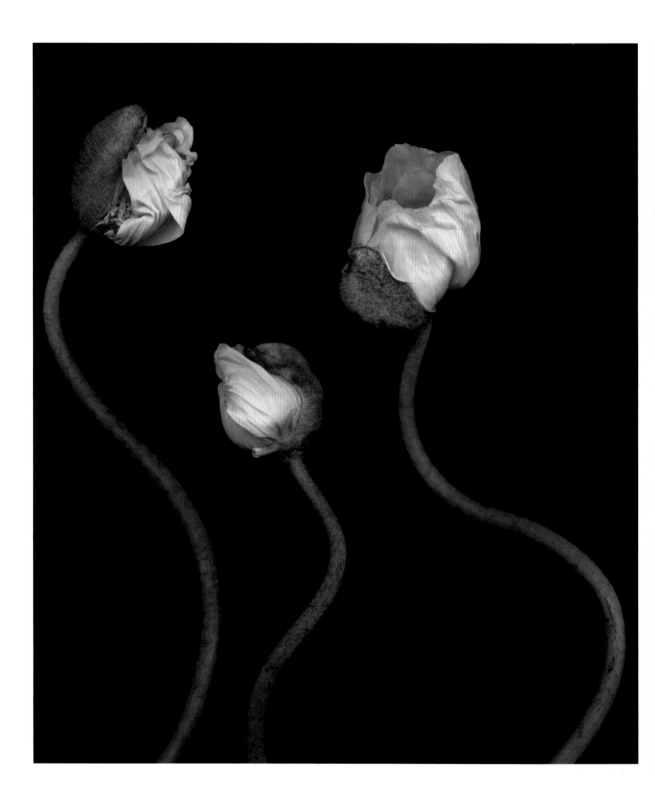

plate 45

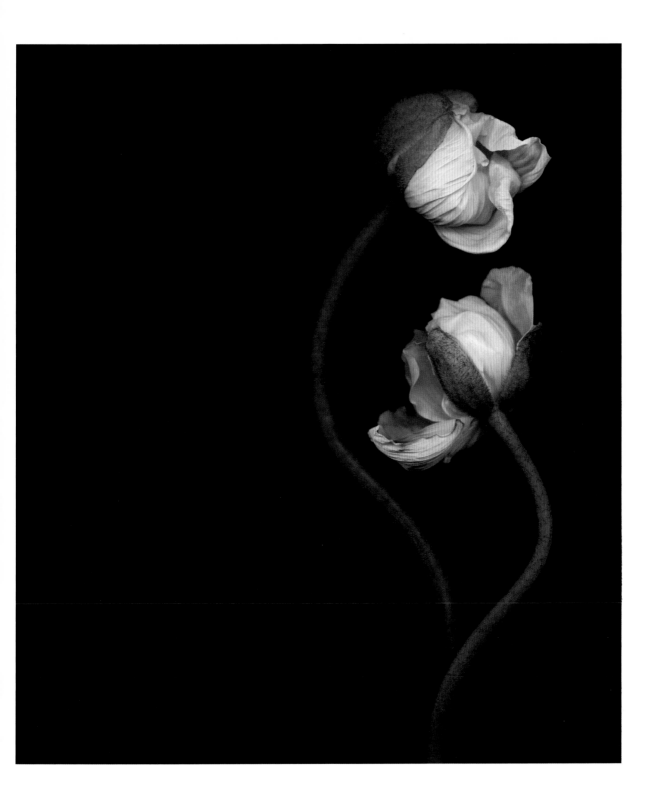

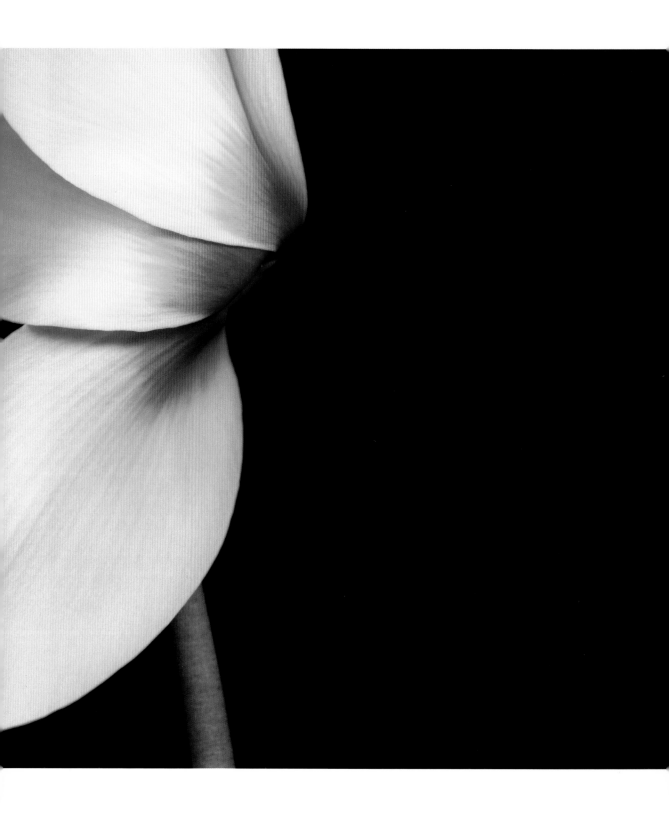

plate 46

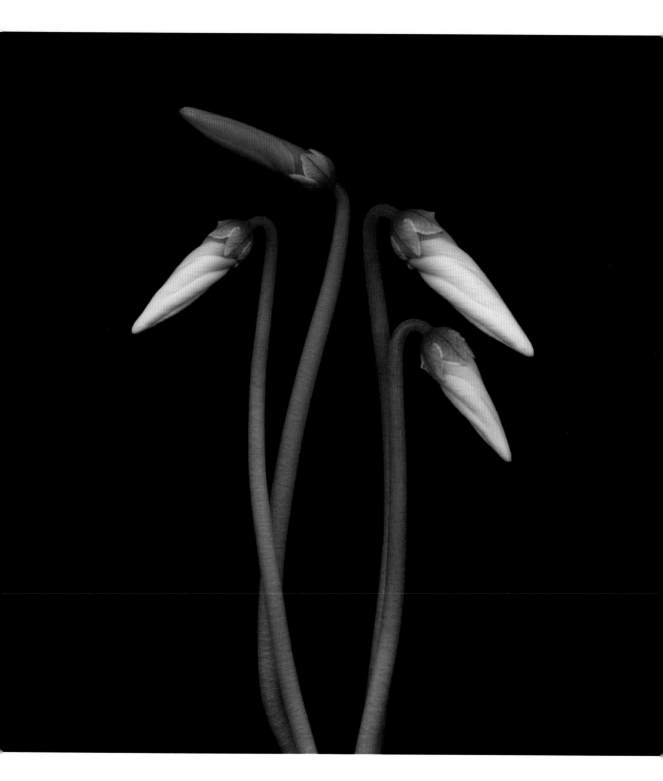

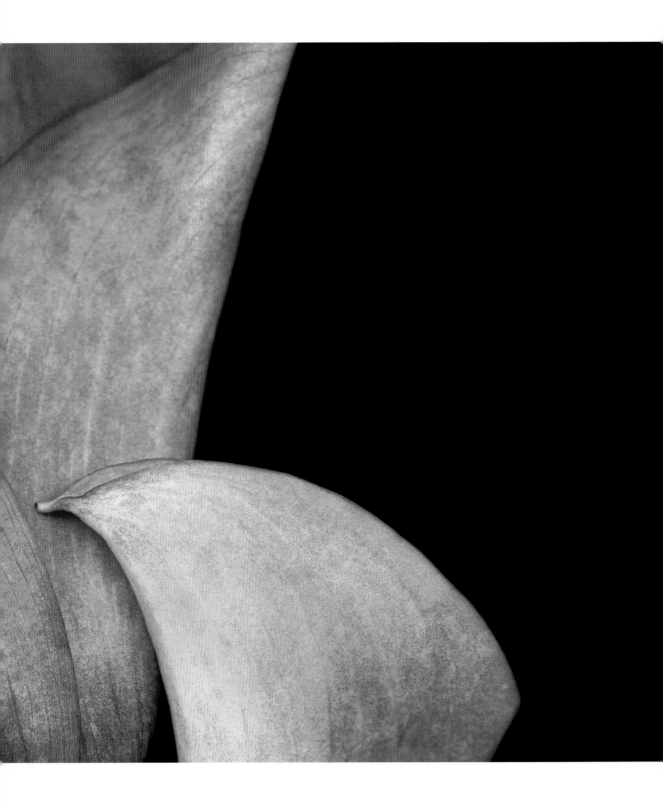

plate 47

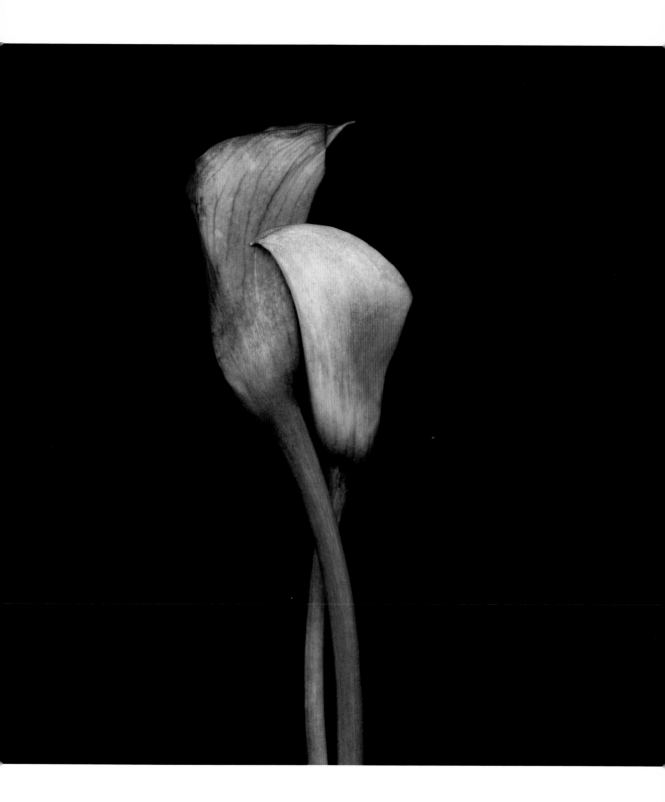

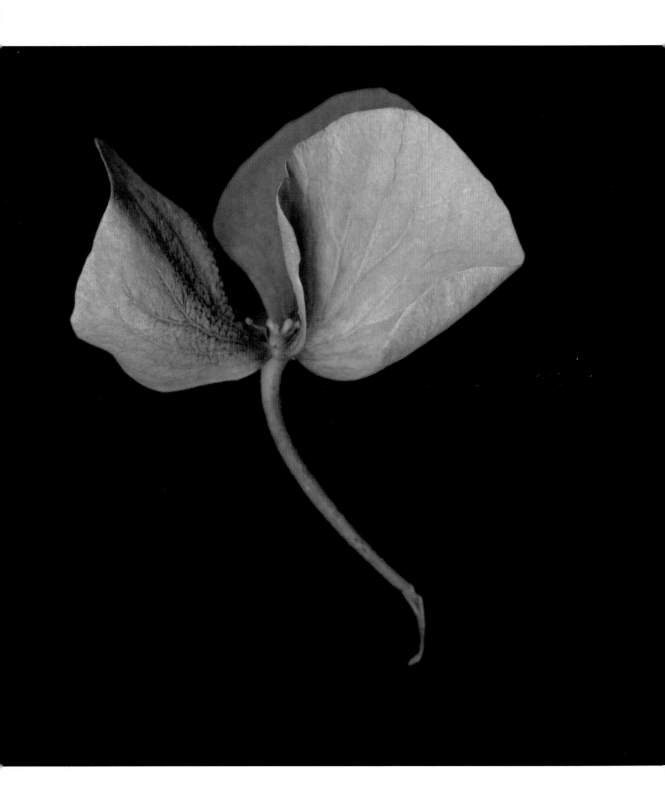

plate 48

There are always flowers for those who want to see them.

HENRI MATISSE

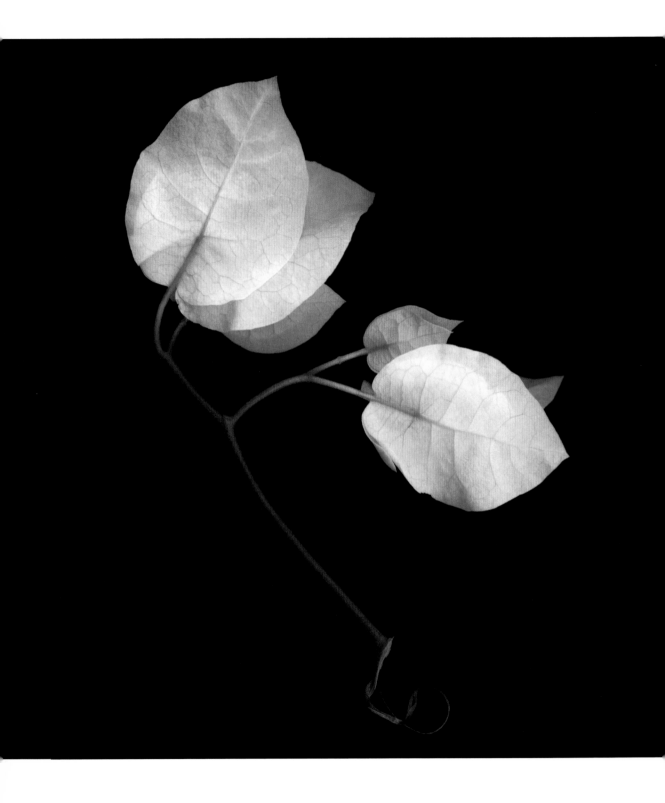

plate 49

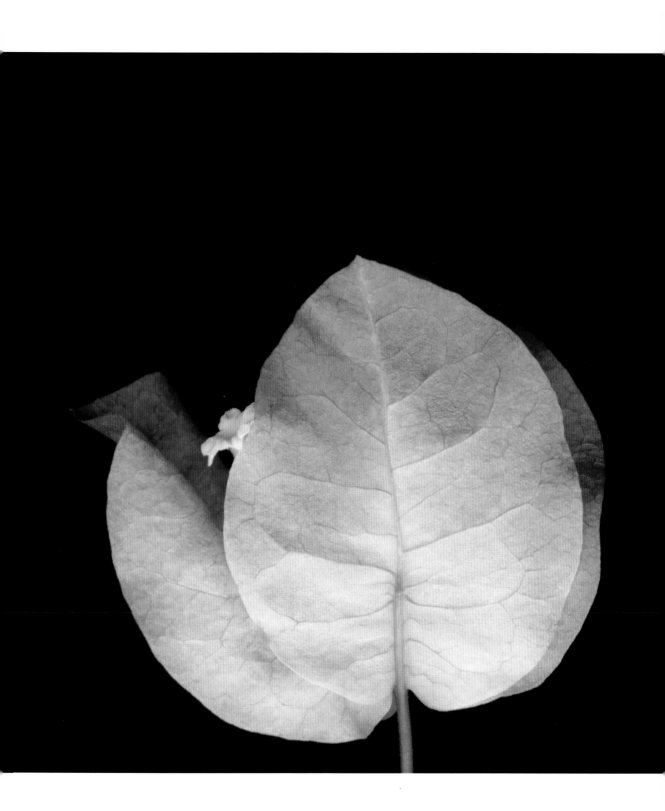

plate 50

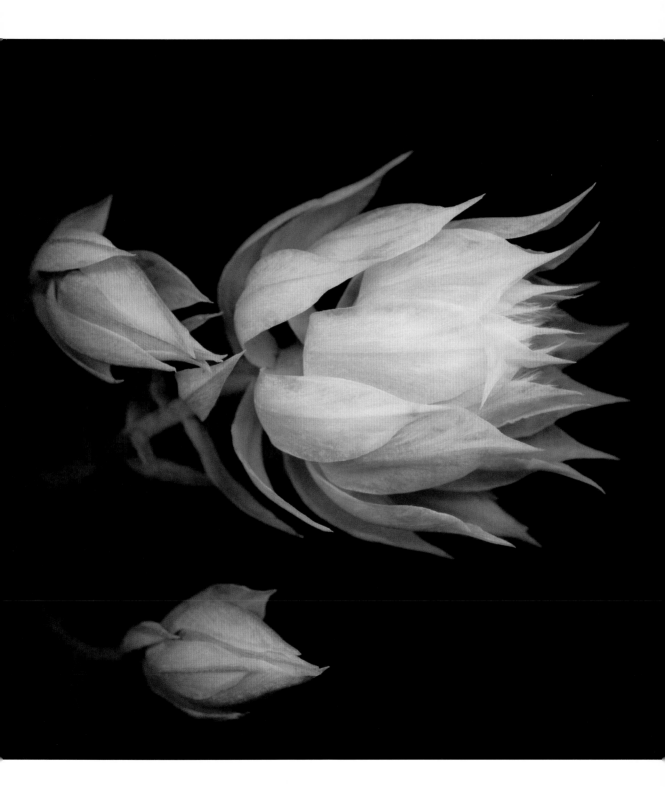

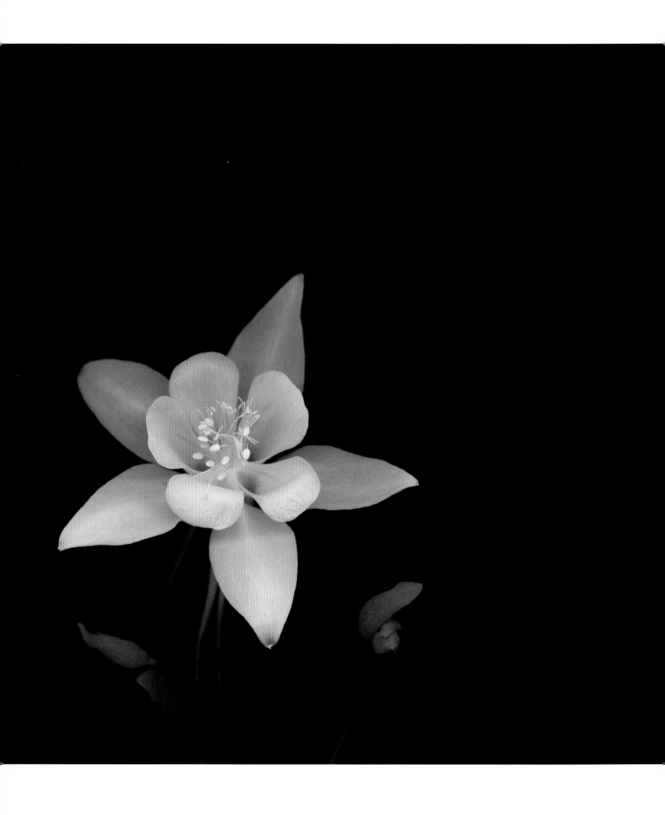

plate 51

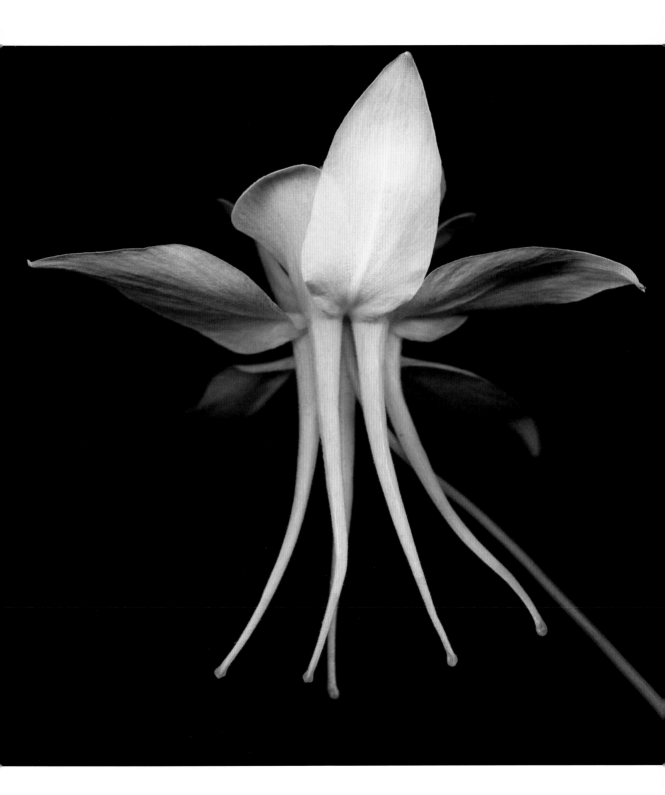

The flower is the poetry of reproduction.
It is an example of the eternal seductiveness of life.

JEAN GIRAUDOUX

plate 52

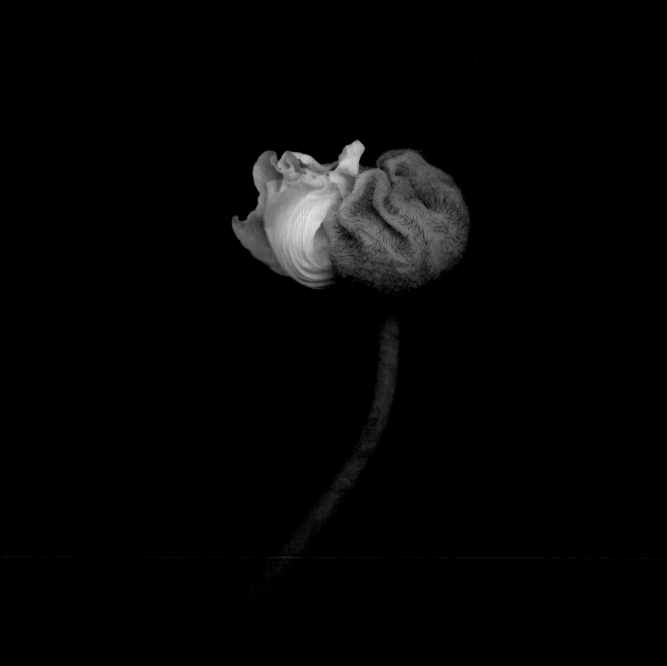

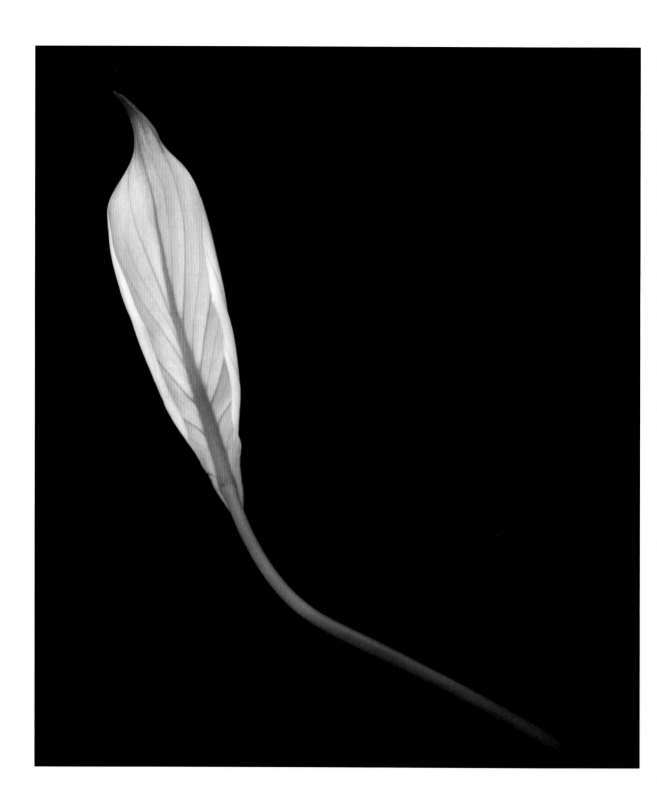

plate 53

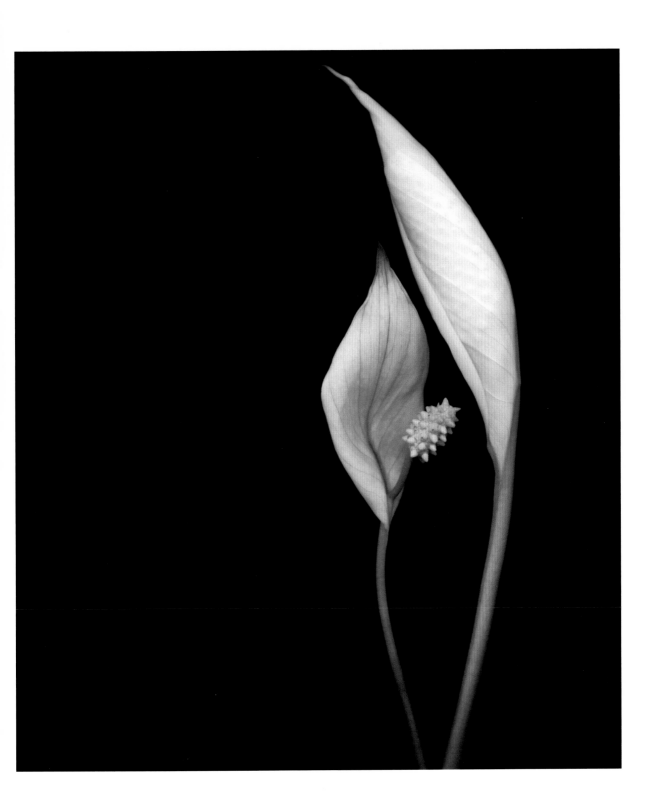

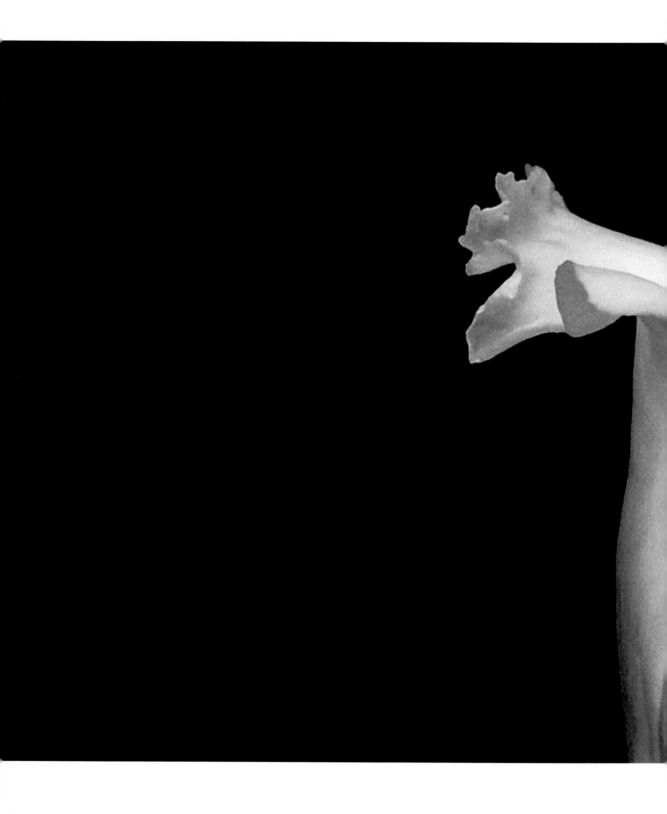

plate 54

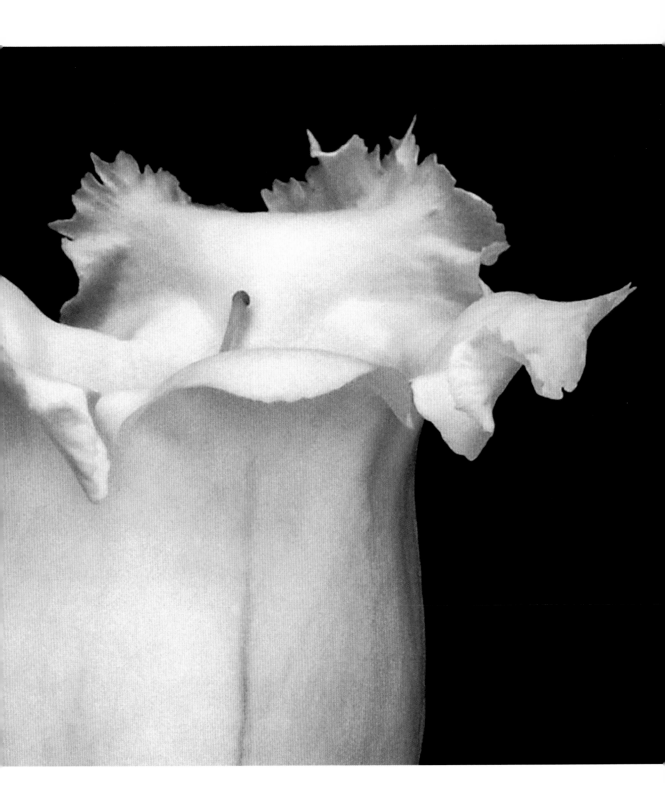

There are only two ways to live your life.
One is as though nothing is a miracle.
The other is as if everything is a miracle.

ALBERT EINSTEIN

plate 55

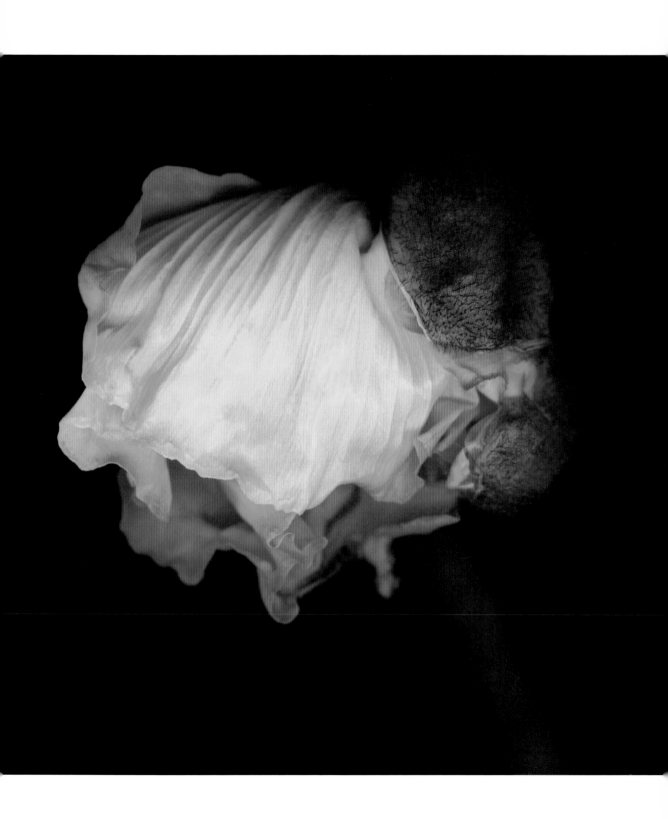

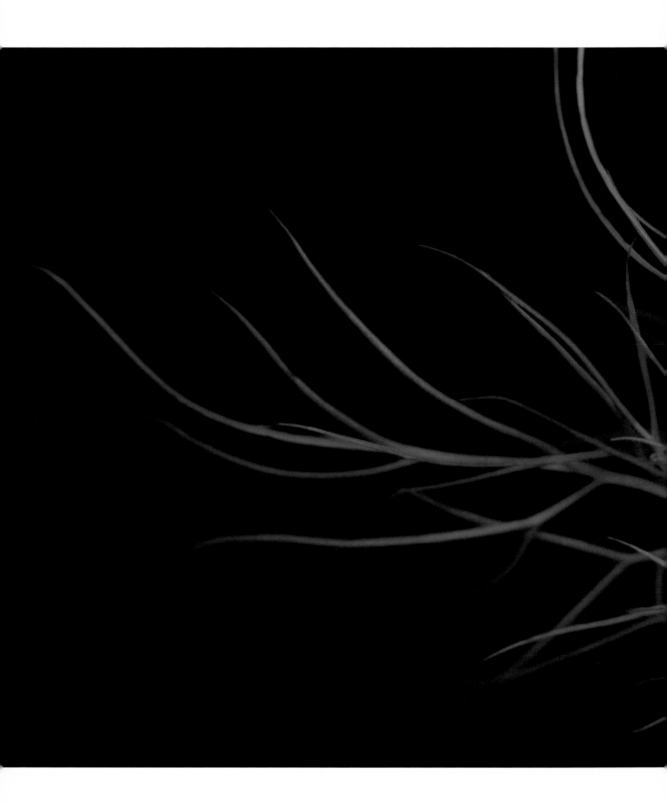

plate 56

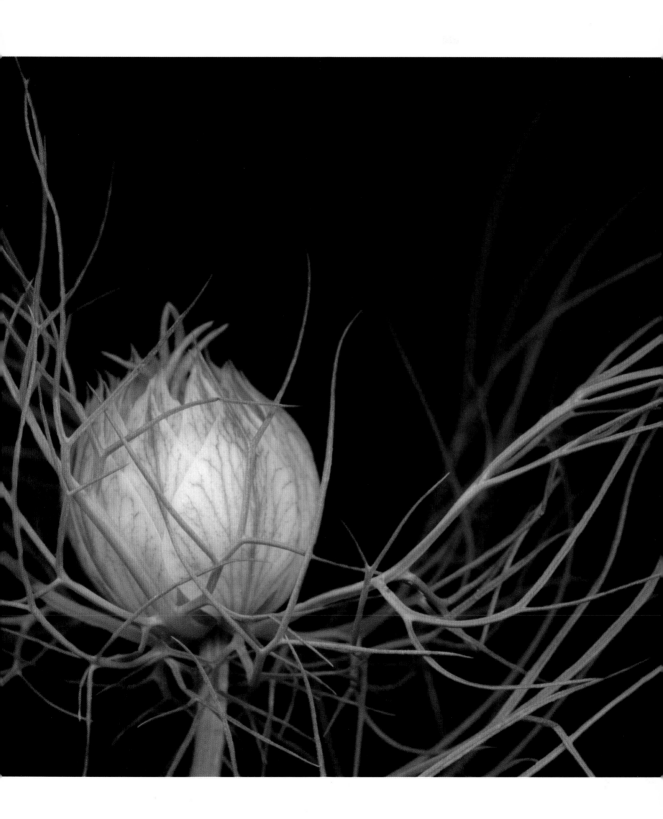

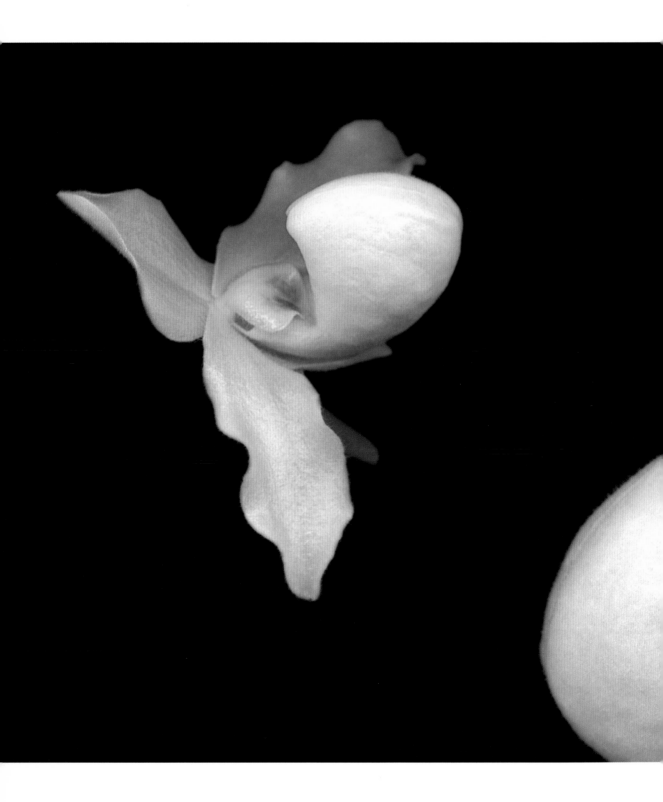

plate 57

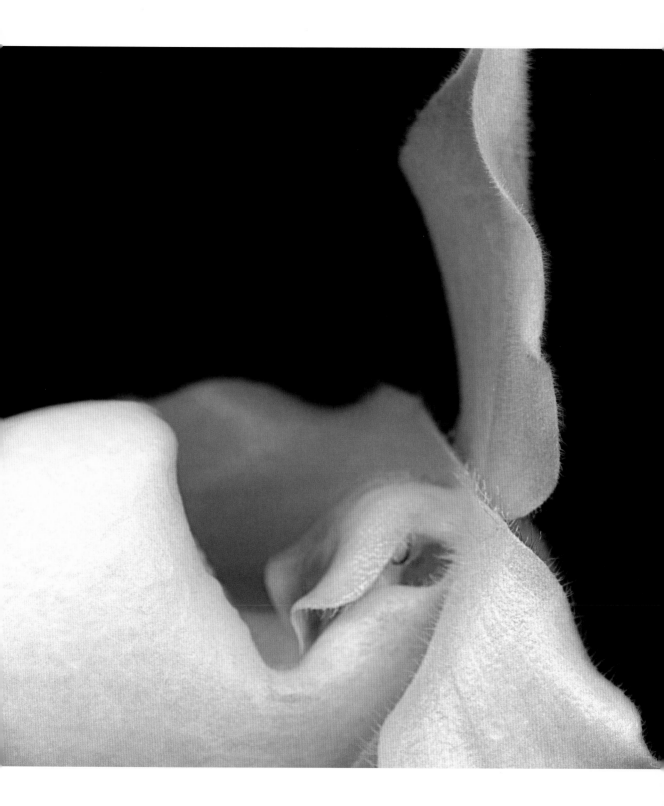

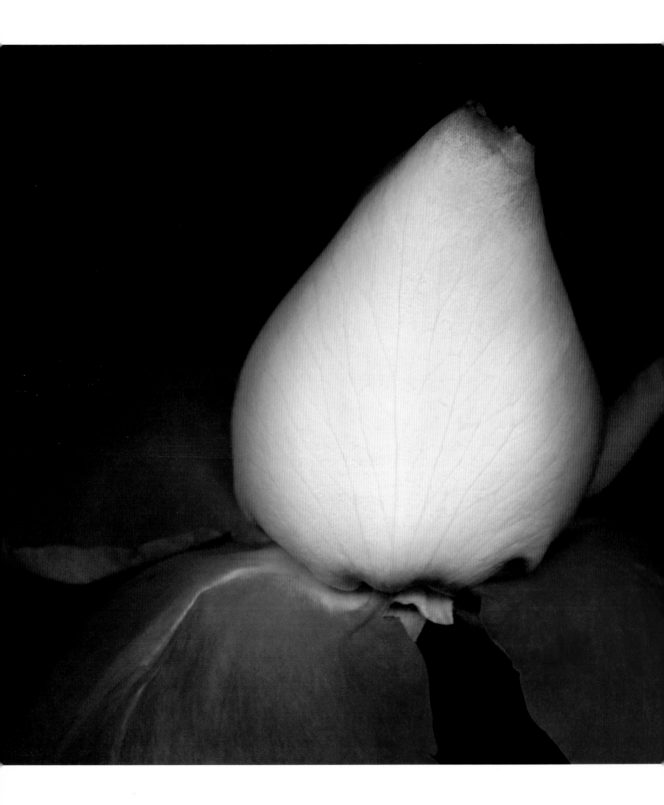

plate 58

In the body of the world, they say, there is a soul and you are that.

<div align="right">Rumi</div>

plate 59

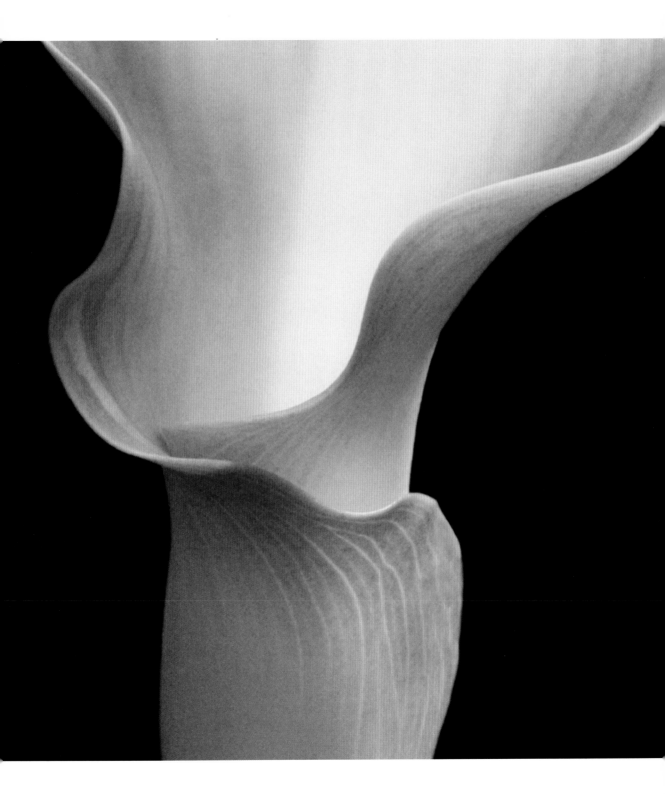

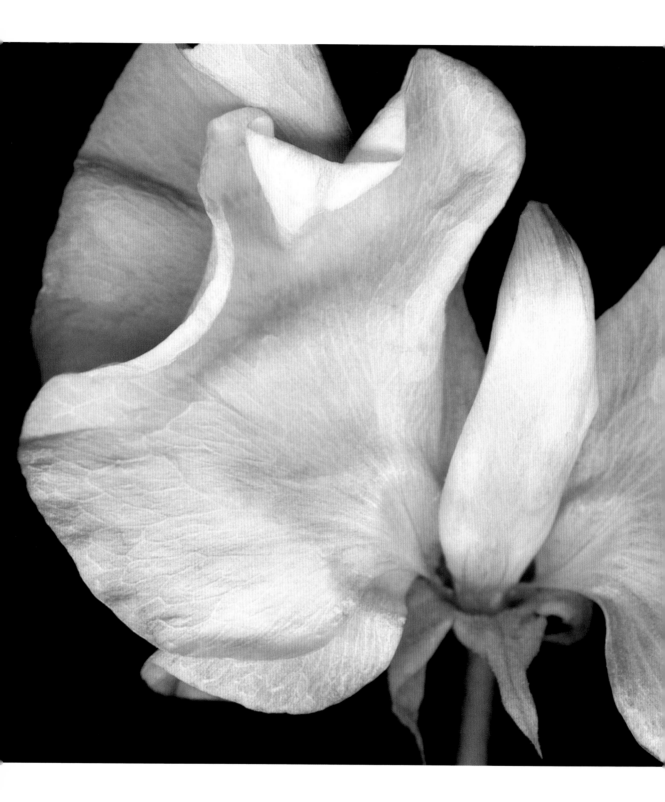

plate 60

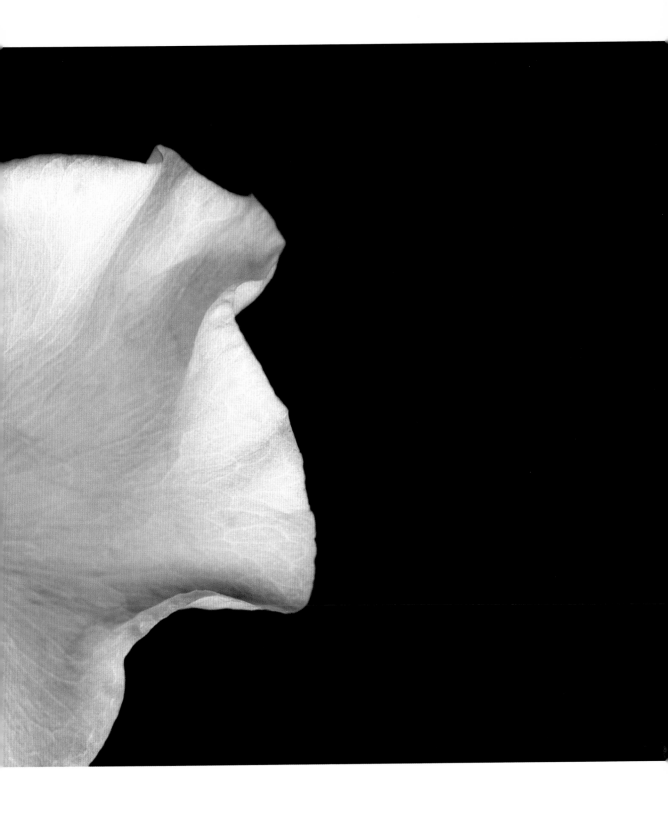

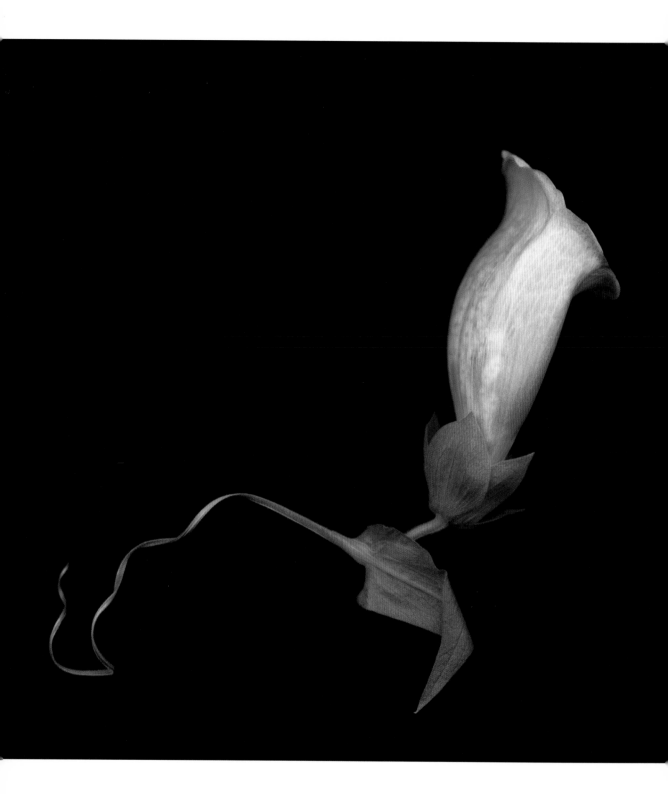

plate 61

PLATES

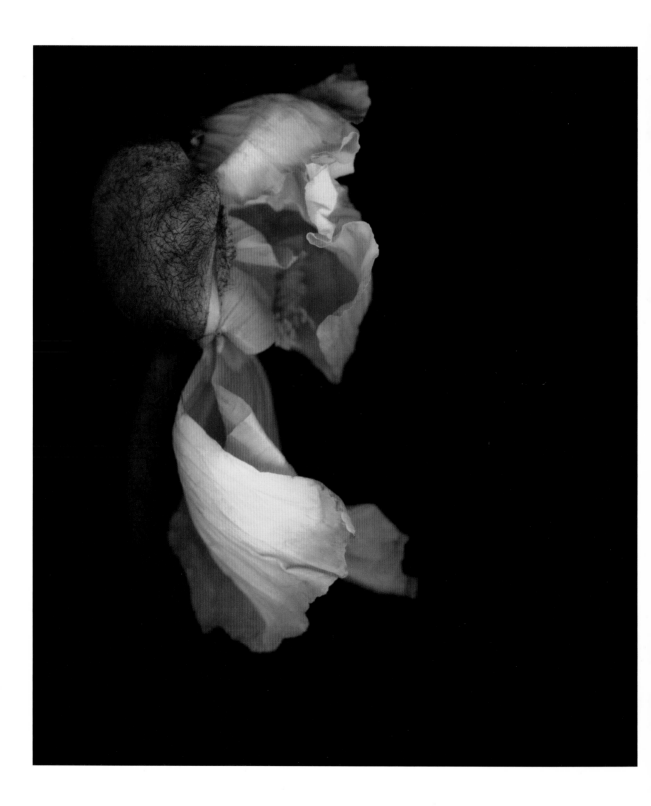

plate 62

The career of flowers differs from ours only in inaudibleness.
I feel more reverence as I grow for these mute creatures whose
suspense or transport may surpass my own.

<div align="right">EMILY DICKINSON</div>

This book is dedicated to the memory of Alexandra Caponigro.

A BARNES & NOBLE BOOK

ISBN 0-7607-6150-7

Printed and bound in China through Asia Pacific Offset, Inc.
10 9 8 7 6 5 4 3 2 1

Joyce Tenneson would like to acknowledge the following people for their valuable contributions.
Designer: Miwa Nishio. Design Assistants: Priscila Gonzalez, Teresa Loewenthal, Christina Richards,
Megan Senior, Diana Teeter.